IMAGES
of America

ST. HELENS

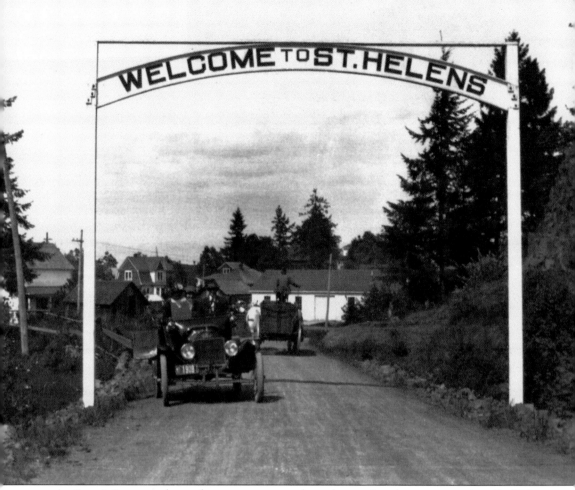

An "autoist" passes a horse-drawn wagon near the welcome sign that once stood on St. Helens Street greeting travelers. The reverse side of the sign carried the message "Come again!" (Courtesy of Loryn Opperman Thurman.)

ON THE COVER: This 1920s photograph of downtown St. Helens shows First Street and the Kaleva Hotel in the foreground. The large St. Helens Hotel is at center, and the McCormick offices are to its right. The iconic basalt courthouse was built between 1906 and 1908. The waterfront did not include the landmark Sand Island—now a marine park—until pumped river dredgings accumulated over the years. In 1921, the US Army Corps of Engineers recommended creating a 300-foot-wide channel that was up to 30 feet deep at low tide. (Courtesy of the Columbia County Museum Association.)

IMAGES
of America

St. Helens

Tricia Brown with the Columbia County Museum Association

ARCADIA
PUBLISHING

Published by Arcadia Publishing
Charleston, South Carolina

Printed in the United States of America

Library of Congress Control Number: 2014957431

For all general information, please contact Arcadia Publishing:
Telephone 843-853-2070
Fax 843-853-0044
E-mail sales@arcadiapublishing.com
For customer service and orders:
Toll-Free 1-888-313-2665

Visit us on the Internet at www.arcadiapublishing.com

*To Pearl Becker, Roy Perry, Susie Dillard, Harvard
Anderson, and the others who strove to collect, protect,
and share the history of a little town on a big river.*

CONTENTS

Acknowledgments

Our warm thanks to the Columbia County Board of Commissioners, St. Helens mayor Randy Peterson, and the members of the St. Helens City Council, as well as the St. Helens Tourism Committee, for their generosity. We are also grateful to Diane Dillard for her personal support, and both to the Columbia County Cultural Coalition and the Oregon Cultural Trust for grant funding. Vern Grimshaw of California was also a supporter. Thank you so much.

The Columbia County Museum Association is an all-volunteer, non-profit organization. Its board includes Joanne LeMont Pellham, president and chair; Les Watters, curator; Barbara Larsen, treasurer; Dave Parsons; Duke Smith; and David Sprau. Each of them contributed immensely to collecting and preparing materials with the assistance of volunteers Clarence "Inkie" Aulenbacher and Tricia Oberndorf. We are grateful for the photographs and memories that have been shared by the many organizations and individuals whose names are credited in the captions.

We encourage you to visit the Columbia County Museum—located on the second floor of the historic Columbia County Courthouse, at 230 Strand Street in St. Helens, Oregon— which sells the complete collection of *History of Columbia County, Oregon* publications. Check www.colcomuseum.org for hours and events. Readers are invited to help with missing names, as well as share their own stories and photographs.

Unless otherwise credited, all photographs were contributed by the Columbia County Museum Association. Von Smith of Columbia Photo Service (CPS) and the St. Helens Public Library (SHPL) also contributed many images.

INTRODUCTION

Viewing the city of St. Helens from the Columbia River, with its iconic basalt courthouse and clock tower rising elegantly above the docks and pleasure boats, it is hard to imagine an expanse of nearly impenetrable, first-growth forest. The craggy face of the basalt cliffs loomed in the north, while a length of beach met the river to the south. Locals say that the explorers Lewis and Clark camped here in 1805, under a particular tree that was protected for the next century, and then cut down—its story lost. Here, 86 miles from the river's mouth on the Pacific Coast, early pioneers found a deep-water port near untouched timber, with a mild climate and a river full of salmon and sturgeon the size of small children.

But this newfound paradise already belonged to someone else.

Along this stretch, the Chinook Indians had dwelt for thousands of years—establishing mature societies in synch with the cycles of river and forest. Explorer George Gibbs, who mapped the area, wrote in 1877, "The position of the Tsinuk [sic] . . . was most important. Occupying both sides of the great artery of Oregon for a distance of 200 miles, they possessed the principal thoroughfare between the interior and the ocean, boundless resources . . . and facilities for trade almost unequalled on the Pacific."

Newcomers arrived with diseases unknown to the Indians. From 1829 to 1834, thousands died from smallpox, measles, and influenza. Nathaniel Wyeth, who settled on Sauvie Island in 1834, wrote that "[A] mortality has carried off to a man [the island's] inhabitants, and there is nothing to attest that they ever existed except their decaying houses, their graves and unburied bones, of which they are in heaps."

More waves of outsiders arrived. Oregon historian Joseph Gaston wrote in 1912 that they at first "detected no differences among these people of the forest and plain. They were all simply Indians." Soon, the differences became more evident. The Upper Chinookan people along the Columbia lived in villages with a governing headman, who acknowledged the power of a regional chief such as Chief Comcomly and, later, Chief Cassino. In this area, Gaston named 59 unique groups whose tribal names were connected to their village sites. Collectively, those who lived on or around Sauvie Island were the Wapato people—named for the abundant root vegetable.

Some 25,000 to 35,000 pioneers entered the Oregon Territory between 1850 and 1855. They pushed the United States government to relocate remaining natives from the land they wished to settle. In 1850, Congress passed the Oregon Indian Act, through which the president appointed a board of commissioners to make treaties and give homeland rights to the non-native settlers. By 1910, the few remaining tribal members were relocated to the Grande Ronde Reservation in a merciless walk called the Oregon Trail of Tears. The St. Helens–area Chinook refused to be grouped with the others and went unrecognized for decades when reparations were paid.

For the non-native settlers, the decision to move west was not for the weak. St. Helens pioneers risked death to venture into an untamed wilderness of dense forests, dangerous currents, and perceived and real enemies. They sailed around Cape Horn from Maine and Massachusetts, or

they journeyed overland, jostling across the prairies and mountains on a raw wagon road in arduous conditions. The new arrivals were European, Canadian, and American, and among them were sea captains, traders, shopkeepers, laborers, homemakers, industrialists, and farmers. Everyone was from someplace else.

Newcomers, particularly the sea captains, saw wealth in the timber. They had traveled the world and knew of potential markets. They bought and built mills, then used their own vessels to transport cargo worldwide. On May 16, 1850, the *Oregon Spectator* advertised that the "Town of Milton is situated on the lower branch of the Willamette River, just above its junction with the Columbia. The advantages of its location speak for themselves. All we ask is for our friends to [come] and see the place. For particulars apply to Crosby & Smith, Portland and Milton."

Soon after came Uncle Sam's offer of free land through the Donation Land Claim Act. Thousands more arrived, and multiple Columbia River town sites, including St. Helens, were surveyed and platted. The numbered north-to-south streets on today's map were not part of the original plan, which used the names of the seasons, various trees and flowers, and the local chief.

For a time, St. Helens was in strident competition with the "Little Stump Town" (as founder Henry Knighton derisively called Portland) as upriver shipping's major port. In 1847, Portland was home to about 100, and were it not for the clever one-upmanship of Portland politicians and the dollars they poured into seizing the title, St. Helens might be the size of Portland today.

The Knighton, Muckle, McCormick, Perry, Ross, Crouse, and Kelley families were the visionaries who built up St. Helens and nearby Houlton—creating an economic and social network in which they and others could prosper. The city would bounce back from disasters such as floods, fire, and economic downturns. Brick and basalt buildings would replace the fragile wood frames. Rails and wagon roads would open up trade and transportation. Families would know friendship and hardship, society and tradition, and through it all, work. Somehow, even through the Great Depression and the war years, local mills, forests, and factories continued to employ hard-working folks—earning St. Helens the nickname "Payroll City."

The decades rolled by, and St. Helens and Houlton merged and became two distinct districts—Downtown and Uptown—with restaurants, local shopping, and chain outlets. Never too big that they would ignore the old-school favorites, locals patronize such long-standing businesses as Dari Delish, Semling's, Richardson's, the Klondike, the Kozy Korner, Bertucci's, Zatterberg's, Sherlock's, and the West Street Grocery. The "country estate" of Hamlin and Nellie McCormick, now within the city limits, is today's McCormick Park—a favorite attraction for its picnic areas, playgrounds, baseball diamonds, trails, and skateboard and BMX tracks.

Even as it matures, St. Helens still recognizes its roots. In 1984, many blocks of familiar businesses and homes were included in the designation of the St. Helens Downtown National Historic District, and leaders continue to seek ways to capitalize on its unique waterfront history. Locals congregate in the plaza and at Columbia View Park for the Spirit of Halloweentown celebration, the Fourth of July fireworks, and music festivals such as 13 Nights on the River. They also join the fun runs and sample food and crafts on lazy summer days.

Today, much of the workforce commutes 30 minutes to Portland or the "Silicon Forest," though the city's small businesses and support services are still healthy. The Cascade Tissue Group paper mill continues to employ, and while the peculiar scent of the pulp mill is no longer in the air, the chip trucks and log trains that still roll through town smell like money.

One

THE FIRST PEOPLE
AND THE SEA CAPTAINS

The Chinook people called the river Wimahl, or Big River. But in 1792, English captain Robert Gray entered its mouth and renamed it for his ship—the *Columbia Rediviva*. Earlier explorers had been unwilling or unable to take on the Columbia's challenging bar, wild tides, currents, and winds. Gray's excursion was a map-changer.

Barely 12 years later, Pres. Thomas Jefferson's Corps of Discovery arrived from the opposite direction, mapping and journaling as they traveled. Lewis and Clark met the Chinook chief Comcomly, as did fur-traders from the Pacific Fur Company who established a post at the mouth of the Columbia in 1811. By then, Comcomly was a local headman of influence, whose power would someday extend hundreds of miles up the river. His daughters' marriages to some company men strengthened trade ties.

The Chinook built spacious longhouses from tall cedar trees and lived communally through the winters. Seasonally, they drew salmon and sturgeon from the river to eat fresh or smoked, and harvested wild berries and root vegetables. Fields of nourishing camas grew on the shallow soil of St. Helens's basalt outcrops. Here was the home of the Nayakaukaue, an Upper Chinookian group. Near the lower mouth of the Willamette was the Cathlacumup. And the Kasenos—whose headman, Chief Cassino, would rise to power after Comcomly's death—dwelt nearby, at the mouth of Scappoose Creek.

In 1829, the five-masted ship *Owyhee* overwintered in Scappoose Bay. During that time, an epidemic broke out among Chinook villages near the vessel and spread up and down the river. During the next five years, entire villages were decimated by communicable diseases, killing an estimated 30,000—Comcomly among them.

Almost immediately, tribal homelands were repopulated by Euro-Americans riding the wave of western expansion during the mid-1800s. Free land was waiting, and they came for it. On wooden ships they came, from Eastern seaports and sailing around Cape Horn to the West Coast. Or overland, in ox-drawn prairie schooners and enduring the treacherous Oregon Trail.

They came to begin again in the Oregon wilderness.

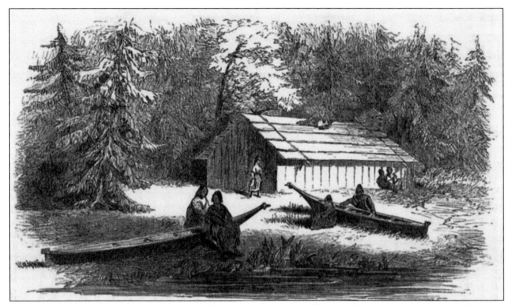

In the early 1800s, visitors to Chinook homelands noted villages of a dozen or more longhouses, with canoes—each carved from a single log—on the beach. Unlike other Pacific Coast Indians, the Chinook did not carve totem poles—preferring to carve and paint elaborate figures on their canoes. (Engraving by Richard W. Dodson, from an Alfred T. Agate sketch.)

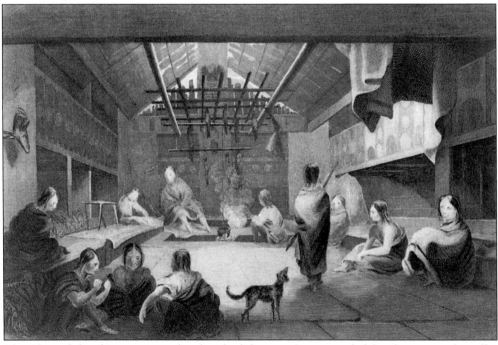

The Chinook lived in massive red cedar plank houses. One extended family or several smaller families shared each house—living in partitioned areas. A central, lower level was for communal fires for cooking and warmth, and there was a smoke hole in the roof. The artist Alfred Agate was a member of the United States Exploring Expedition in the late 1830s and early 1840s. (Engraving by Richard W. Dodson, from an Alfred T. Agate sketch.)

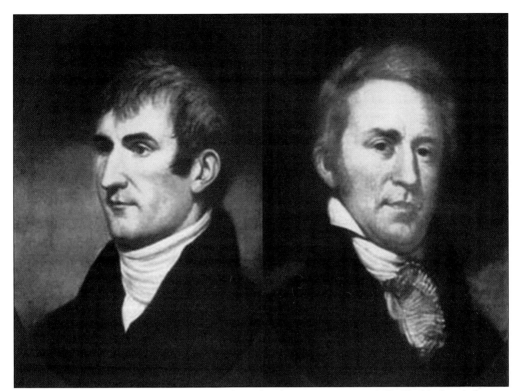

Meriwether Lewis (left) and William Clark sat for these portraits in 1807. Clark's detailed notes on the region mention several familiar landmarks, including Wapato (Sauvie) Island and Wapato Inlet (Multnomah Channel). While outbound in 1805, Clark noted a channel behind a "rocky, sharp point" (Warrior Point of Sauvie Island), but did not explore further. Returning, they encountered many Indian villages on both sides of the channel. (Charles W. Peale, courtesy of Independence National Historic Park.)

In 1814, Samuel Lewis created this map from original Corps of Discovery drawings. This portion shows "Wapatoo I." Just beyond the island's tip, St. Helens would later be settled on the west bank of the Columbia. (Courtesy of the Library of Congress.)

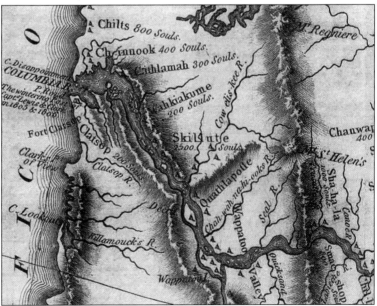

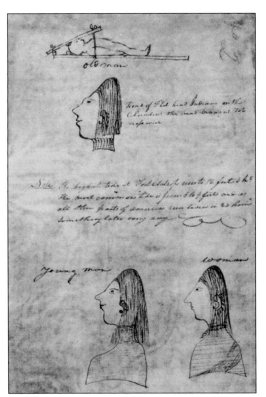

While camped at Fort Clatsop in 1805 and 1806, William Clark made notes about local tides and sketched the people. Columbia River tribes defined beauty and identified affluence by flattening their heads into a wedge shape. The process began soon after birth, though slaves were not allowed the privilege of head flattening. (Courtesy of the Oregon Historical Society.)

Local history claims that Lewis and Clark camped beneath this tree on the Strand, near Muckle Brothers Store and Lumber Office. A March 25, 1905, newspaper report noted that the tree was to be cut down and exhibited at Portland's Lewis and Clark Centennial Exposition. What became of the landmark tree is unknown.

Dr. John McLoughlin was a firm hand at Fort Vancouver, interacting daily with fur traders, natives, and settlers on behalf of the Hudson's Bay Company. After the fort was relinquished to the Americans, McLoughlin moved to his Oregon City property. He was a medical doctor and leader for many years. In 1957, the Oregon legislature named him the "Father of Oregon." (Courtesy of the Oregon State Library.)

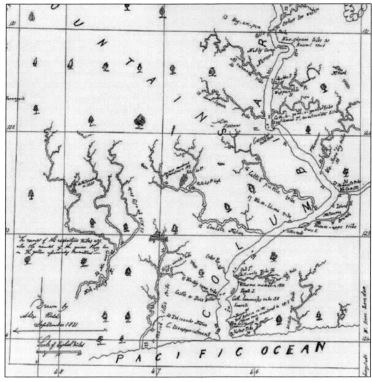

Scotsman Alexander Ross mapped the Columbia in 1821, having traveled extensively as a trader. In July 1811, he wrote: "we encamped at the mouth of the Willamitte [sic]. The waters of the Columbia are exceedingly high this year—all the low banks and ordinary watermarks are overflowed . . . in the present state of flood, surrounded on all sides by woods almost impervious, the prospect is not fascinating."

13

Strong trade ties existed between New England, the Oregon Territory, and the Kingdom of Hawaii (then called Owyhee). In 1829, Capt. John Dominis was master of the *Owyhee*, a wooden sailing ship sent to trade with the Hudson's Bay Company at Fort Vancouver. The ship wintered in Scappoose Bay from 1829 to 1830, and native oral history claims that rampant disease was traced to it. (Courtesy of the Dominis Family.)

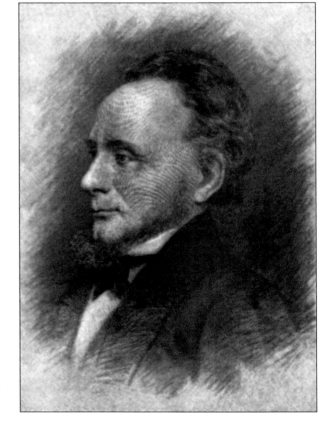

Bostonian Nathaniel Wyeth first chose the spot of the future St. Helens. When Henry Knighton arrived, the area was called Wyeth's Rock. In 1834, Wyeth settled on Wapato (now Sauvie) Island and found empty villages and scattered bones. He built Fort William—first on the Columbia River side and later on the Multnomah Channel side—but was unable to compete with the Hudson's Bay Company and sold out by 1836. (Courtesy of the Cornell University Library.)

Capt. Francis Lemont, pictured here in 1865, came to St. Helens in 1829 as an 18-year-old seaman. When his ship, the *Owyhee*, went aground at Deer Island, a message was carried to Fort Vancouver, and John McLoughlin sent men and fresh food. Lemont thanked McLoughlin with three peach trees he had brought from a Chilean island. Planted at Fort Vancouver, the trees were the first on the Columbia. Generations of Lemonts, now LeMonts, raised their families here. (Courtesy of George LeMont Sr.)

Nathaniel Crosby (pictured) and Thomas Smith partnered with two other sea captains to purchase the Jacob Hunsaker mill in Milton, and then aggressively competed for business. Posey Williams, master of the *Louisiana*, was also part of building up Milton. In 1854, Milton became the first county seat, but three years later, voters moved the seat to St. Helens. Little remains of Milton—now on commercial property at the end of Railroad Avenue. (Courtesy of the Oregon Historical Society.)

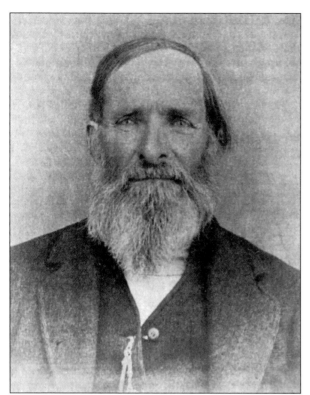

W. Francis Perry and family arrived on a raft bearing his handmade prairie schooner. Their Oregon Trail journey began in May 1845 at St. Joseph, Missouri, with 223 wagons carrying 934 people who were divided into three companies. At Milton, Perry built a house and sawmill, and enjoyed the lumber boom during the California gold rush.

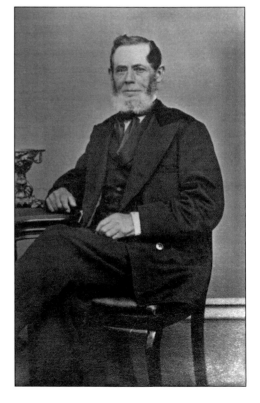

In the 1850s, Capt. Seth Pope built a grand "knock-down" house overlooking the Columbia, using pre-fabricated panels from Maine. The downstairs housed offices, while a courtroom and schoolroom—where attorney F.A. Moore taught—were upstairs. Pope also had a store and post office nearby.

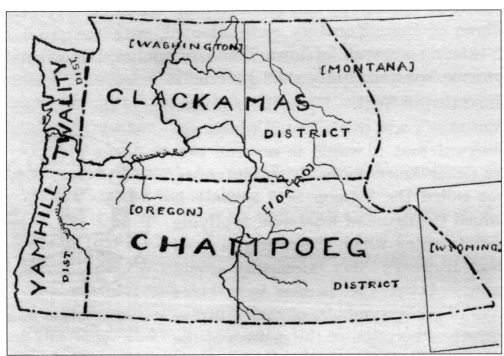

In 1843, the Oregon Territory included Washington and was divided into districts for provisional government. St. Helens was part of the Twality (or Tuality) District before counties were formed. Later, it was part of Washington County before Columbia County was formed in 1854. (Image from *Oregon: Her History, Her Great Men, Her Literature*.)

With the passing of Chief Comcomly in 1829, Chief Cassino rose in power. He ably oversaw a large number of Lower Columbia Chinooks while dwelling near St. Helens. Pictured is a reproduction of an 1846 sketch by Paul Kane. (Courtesy of the Oregon Historical Society.)

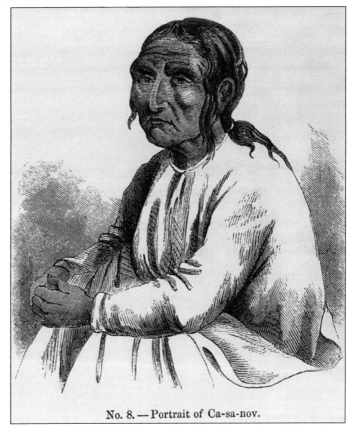

No. 8. — Portrait of Ca-sa-nov.

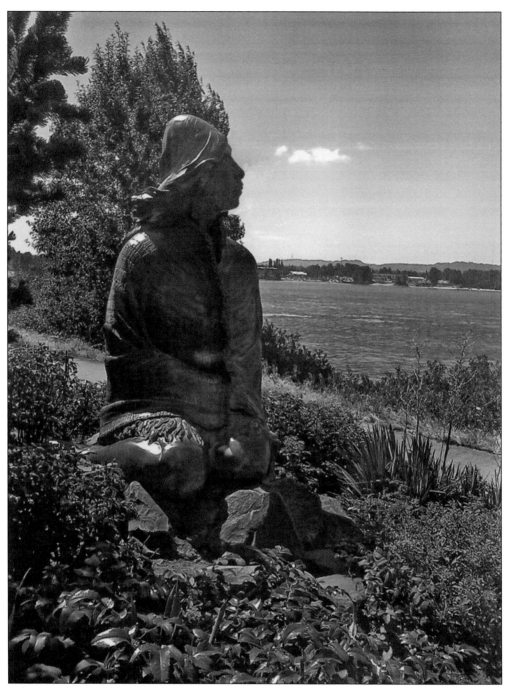

Ilchee, or Moon Girl, was a favorite daughter of Chief Comcomly. This seven-foot bronze statue by Eric Jensen, installed in 1994, honors her memory as one who paddled her own canoe. Abandoned by her white, fur-trader husband, Ilchee married Chief Cassino. When he threatened her life, she escaped to Fort Vancouver and later returned to her family near Astoria. She overlooks the river from the Vancouver side. (Courtesy of Tricia Brown.)

Two

CAPTIVATED BY
THE RIVER AND FOREST

Oregon Trail pioneer Henry M. Knighton is credited with founding St. Helens. In truth, several founders—both sea captains and overlanders—helped grow the outpost into a town.

Nathanial Wyeth first landed in 1834, naming the area Wyeth's Rock before deciding to build on Wapato Island. In 1847, Bartholomew White was already running a gristmill and sawmill that Knighton acquired. In 1848, at Milton Creek, Joseph Cunningham's mill was passed on to Jacob T. Hunsaker before it was purchased by four young, ambitious sea captains who had connections in the timber and international shipping industries. Nathaniel Crosby and Thomas Smith laid out Milton (Milltown) City and offered free lots in the *Oregonian*. The community had a population of 102 by 1850—with only four residents over the age of 40—making it much larger than Knighton's town.

What set Knighton apart was his vision for making St. Helens the center of trade on the Lower Columbia. He hired Peter W. Crawford and William H. Tappan to survey and lay out the town while artist Joseph Trutch mapped it. Knighton also advertised for settlers and tested several names before settling on St. Helens.

Soon, other influential pioneers arrived—Seth Pope, Ben Durell, and Francis Lemont among them—and Knighton secured a contract with the Pacific Mail Steamship Company to use the town as the company's northern terminus. Next, he was stumping for a railroad.

The Oregon Territory was flooded with newcomers. California's gold rush was on. Business boomed. Led by shrewd politicians, the frontier town of Portland began rigorously competing with St. Helens. By 1853, they had persuaded the *Peytonia* to make a regular San Francisco-to-Portland run. Pacific Mail wanted more freight and passenger business, too, and countered with a St. Helens-to-Portland run on the *Fremont*. During this period, Knighton's docks burned twice under mysterious circumstances. As the shipping center shifted to Portland and railroad plans failed, it spelled the end of Knighton's dream.

This was not the end for St. Helens or its neighboring towns, however. The river and forest provided for them. Flooding would wipe out Milton before 1900, and its residents would resettle at Houlton. The town thrived until it was joined to St. Helens, fortifying both.

In the end, St. Helens would secure a vital position on the great river of the West.

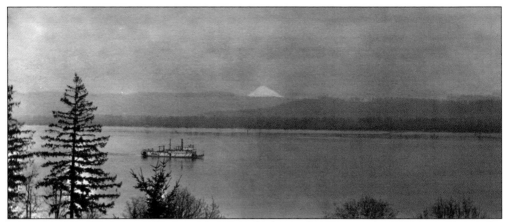

Here, a paddlewheel steams by St. Helens—with the peak of Mount St. Helens visible on the Washington side of the Columbia. The great river was a busy corridor for immigrants arriving by steam and sail. (Courtesy of the Ross Family Collection.)

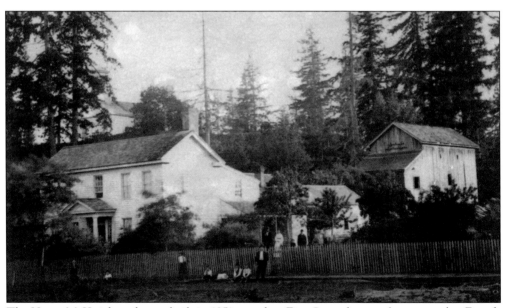

The Henry M. Knighton home, built in 1851, stood on First Street but was later moved to Fourth Street. Knighton was credited with founding the town in 1847, when he built a log cabin at Wyeth's Rock. Historians suggest that Knighton "crowded out" pioneer Bartholomew White, who had built a gristmill and sawmill here in 1844. Several accounts describe White as physically handicapped, without further detail. The impairment may have led him to abandon his claim.

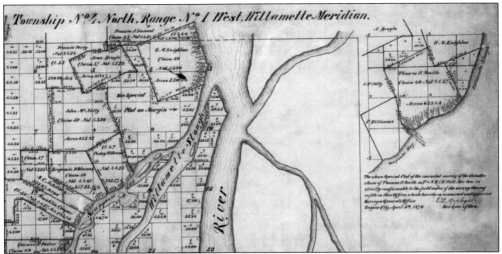

Settlers in the West could apply for free land through the Donation Land Claim Act from 1850 to 1855. DLC applicants could claim 640 acres for a man and wife, or 320 for a single man. Preemption Land Claims allowed squatters who predated the DLC to purchase their land. The mix of land claims resulted in odd-shaped boundaries on maps such as this 1897 St. Helens survey. The balance of land was settled under the Homestead Act, or the Timber and Stone Act. (Courtesy of University of Oregon Libraries.)

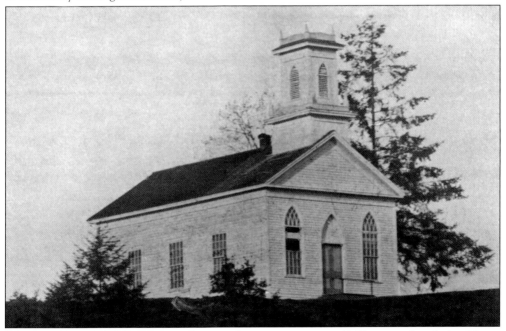

For 46 years, starting in 1853, St. Helens worshippers met in a small Christian church that Henry Knighton built on Nob Hill above downtown, where the Rutherford House now sits. Local carpenters contributed their skills and neighbors helped fund the building. It was the town's only house of worship for nearly a half century. In the 1870s, it served as the schoolhouse as well. On July 15, 1899, the whole town grieved when fire consumed their beloved landmark church. The *Oregon Mist* remarked: ". . . there is not an old-timer in this section of the country, who does not deplore the fact and lament the loss, equal almost to the demise of some true and tried friend."

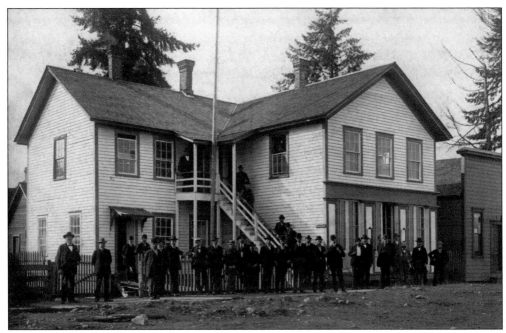

Capt. Seth Pope's home was St. Helens's first courthouse. The wooden structure stood at the east end of what is now the town plaza, facing the river. It was spared when an entire block burned in 1904, spurring city leaders to build a stone courthouse. In 1905, the main section of the old courthouse was moved to the Strand's east side, while two additions were repurposed as residences. Over the years, it was a bank, bakery, pool hall, restaurant, and feed house. In late October 1933, trucks lined up to salvage the still-sound Maine lumber after a wrecking crew razed the building.

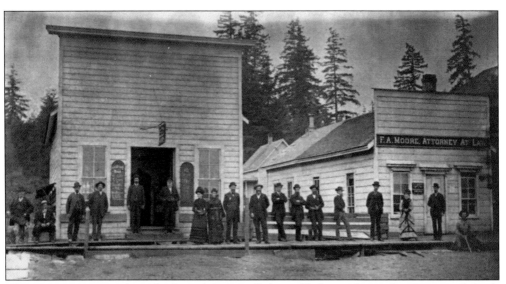

This 1884 street scene along the Strand shows well-dressed ladies and gents lined up outside both Tom Cooper's Saloon and the law offices of Moore and Quick.

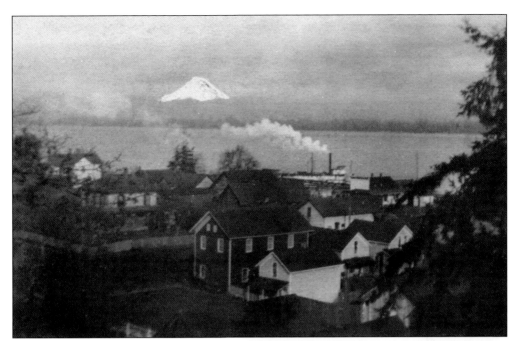

By 1885, St. Helens was seeing significant growth. The Seth Pope courthouse is visible at center left in this photograph. The dark building at center was Abe King's blacksmith shop, at the corner of First and Cowlitz Streets.

Elizabeth Perry learned how to tend to medical needs while traveling west on the Oregon Trail. After arriving with her husband, Francis, she continued doctoring—specializing in women and children. Perry also raised 14 children on the family's Donation Land Claim in Houlton. (Courtesy of the Perry Family Collection.)

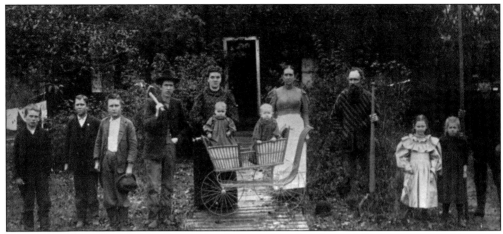

Here, three generations of the Crouse family are gathered in front of their vine-covered home in Houlton. Note the baby carriage for two, and that each adult male is holding a tool, presumably from his vocation in quarrying or logging. (Courtesy of Gayle Smith Harbison.)

St. Helens Masonic Lodge No. 32 was established on March 2, 1860, and members built this hall in 1866. It survived into the 1950s, when it was occupied by Gill Hardware. In 1869, a group of 26 members formed the Order of the Eastern Star Mizpah Chapter 30, when a group of Master Masons' wives felt the need to "better assist the brothers in the discharge of Masonic charities." A new, more elaborate Masonic lodge was constructed on First Street and dedicated on October 18, 1913. It is still in use today. (Courtesy of Joyce Heumann Heller.)

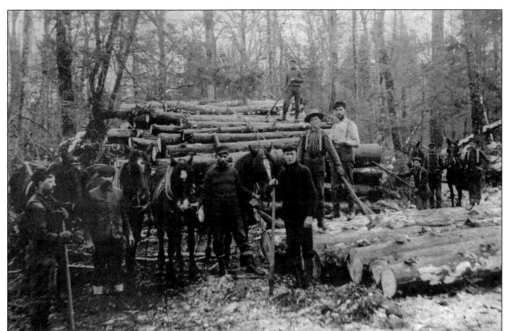

Abraham Crouse ran a logging operation on Milton Creek in the early 1900s. He and his second wife, Bethiah, brought their family from East Washburn (Crouseville), Maine, to Yankton, Oregon, in 1892. Later, they moved to Houlton. (Courtesy of Gayle Smith Harbison.)

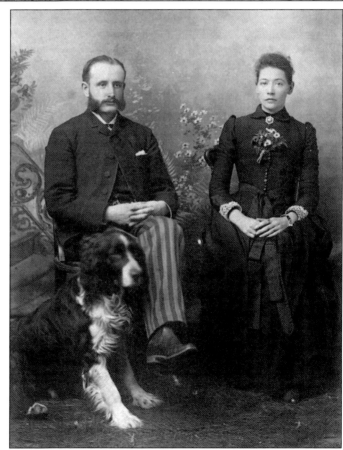

Here, Dr. Harry R. Cliff and his Australian wife, Clara, pose for a formal portrait. Cliff was the first certified doctor in St. Helens. Born in England in 1860, he graduated from Bartholomew's Medical College in London and came to St. Helens in 1884. The Cliffs built a home on South First Street, which is still standing. Dr. Cliff practiced medicine here until 1908, when he moved his family to Portland.

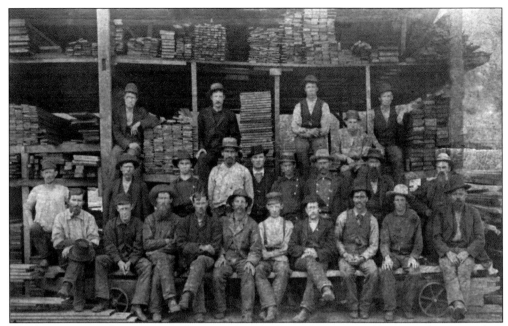

The first major employer in St. Helens was the Charles and James Muckle Sawmill. The workers gathered for this group photograph in 1879. The Muckles had purchased the mill in a sheriff's sale after it had lingered in litigation. The mill was deemed a total loss after the 1904 fire that swept the riverfront business district.

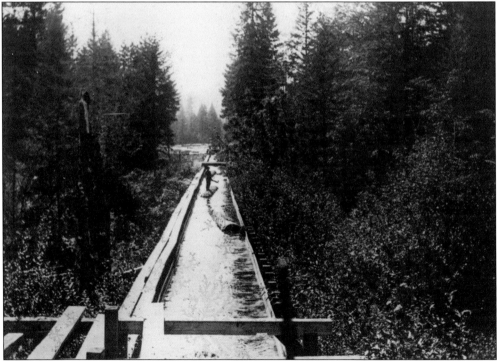

Multiple flumes were used to transport logs from local camps to the waterfront. A series of gates dammed the flow until a strong current was needed to move the logs.

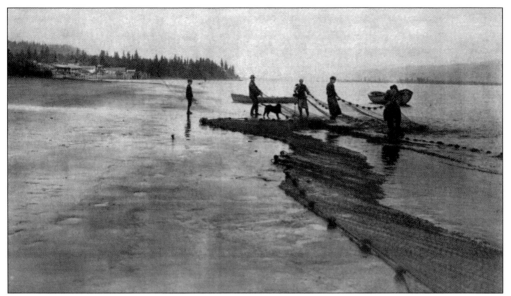

Beach seiners used skiffs and manpower to net salmon from the shoreline. In 1889, the Astoria newspaper reported that, "Since the Muckle Bros. have been running logs in Milton Creek, the fishermen who are fishing at the mouth of the creek have been having extraordinary luck, sometimes catching with their nets as high as two tons of salmon in one day." Apparently, when mill operators released water from their dam gates, the fish moved upstream "with all possible speed," sometimes jumping up to six feet to clear the gates.

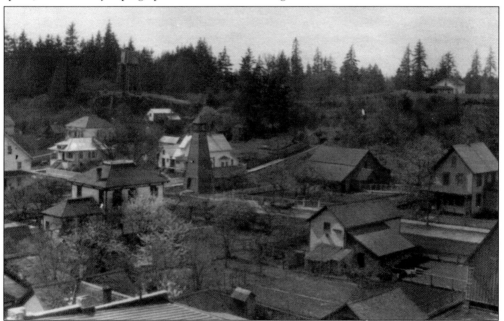

Looking southwest in 1909, this view includes the water tower on the bluff. The original system used a small pipe to carry water from a dam on Milton Creek. The lower tower housed the fire engine beneath the alarm bell and hose-drying structure. At far right is the home of James Muckle. The square, two-story white house belonged to Richard and Anna Muckle Cox. It was built in 1890 and, 12 years later, was moved to its current location a few lots north.

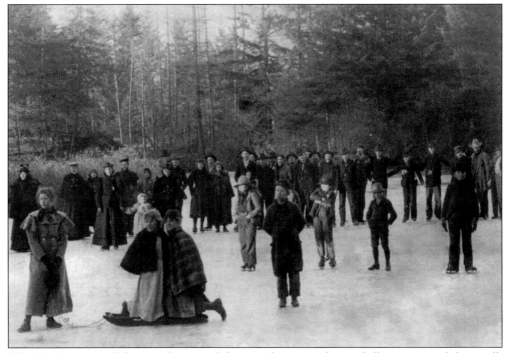

Whether they were sliding on shoes or gliding on skates, residents of all ages enjoyed the small, frozen ponds around town. At one time, Columbia Boulevard bridged this pond, which has been misidentified as Dalton Lake. Before it was drained and filled in 1912, it was located behind the Dillard home, on the South Second Street side.

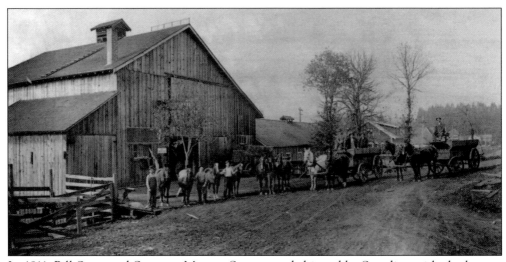

In 1911, Bill Stout and Swepson Morton Sr. operated this stable. Standing with the horses, from left to right, are Ed Bouldy, S.N. Cade, Doc Cram, and Elmer Blackburn. Joe Stevens and Harvey Hooper are at the reins of the two wagons. Two individuals standing in the left wagon are unidentified. The livery was virtually next door to the old John Gumm School at Third and St. Helens Streets.

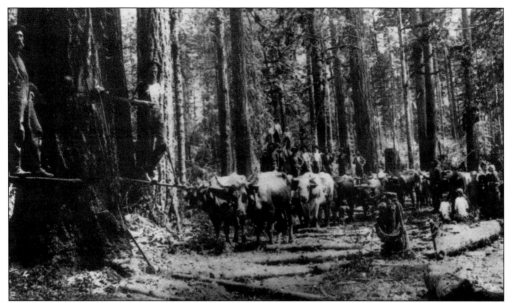

In this 1890 photograph, loggers use teams of oxen to transport timber on a site that would one day be the St. Helens Golf Course, and later still, the current St. Helens High School. Ralph Hazen (left) and Everett Emerson are seen on the springboard. The large group of men in the background is comprised of, from left to right, (first row) five unidentified men from Maine, Rudolph Kappler, and I.G. Wikstrom; (second row, standing on the stump) Frank Wikstrom, Cal Howard, and Charles Wikstrom. Looking on at right are some loggers' wives, children, and other friends. (Courtesy of Jeannette Barker.)

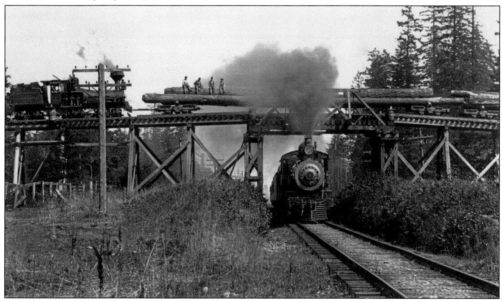

The Astoria and Columbia River No. 8 is seen pulling the Seaside-to-Portland passenger train as it passes under a C.C. Masten Logging Company train near Houlton in 1908. On a modern map, the Masten line would have run along Sykes Road and crossed Highway 30. According to one authority, most of the area's logging operations "preferred to dump their logs into the Columbia River to be rafted rather than pay the expense of haulage by other railroads."

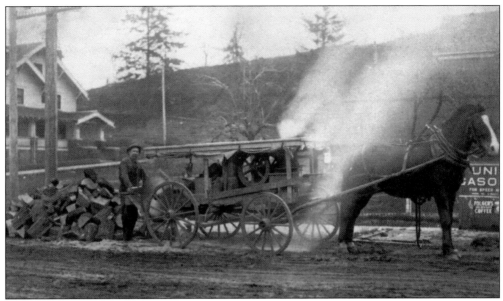

Henry Christie, who arrived around 1910, operated a horse-drawn, gas-powered saw on a lot where the McCormick Building would be constructed in 1921. Locals used the stove-length cuts for heat and cooking. At left stands the Amy George House. Note the advertisements for Union Gasoline and Folger's Coffee at right. (Courtesy of City of St. Helens.)

Samuel Miles was an overlander, as the Oregon Trail immigrants were known. As a new arrival in Milton, he worked for Francis Perry, then left to go mining. Back in St. Helens by 1860, Miles made his fortune in stock ranching on Deer Island. He was Columbia County's deputy sheriff in 1860 and was elected sheriff in 1862. In 1886, Samuel and Elizabeth built this elegant Victorian home on South First Street. They were the parents of 10 children, many of whom gathered for this 1911 Christmas photograph.

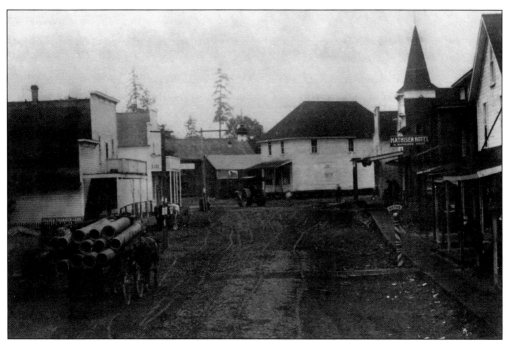

Flooded-out residents of Milton resettled upstream in the late 1800s, but postal regulations would not allow them to reuse the town's name. The postmaster instead named the place for his Maine hometown: Houlton. It was incorporated in 1904.

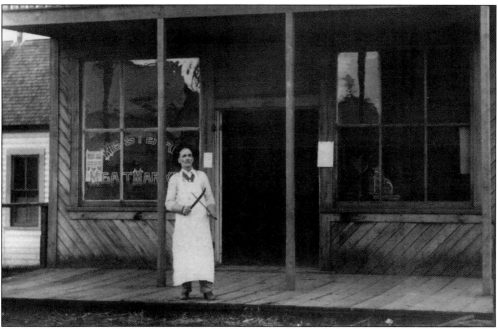

Here, a butcher poses with the tools of his trade at Houlton's Western Meat Market. The town covered an area of 160 acres and had a population of 347 in 1910. Other businesses included two general merchandise stores, three saloons, three hotels, a barbershop, a bakery, a restaurant, and two blacksmith shops.

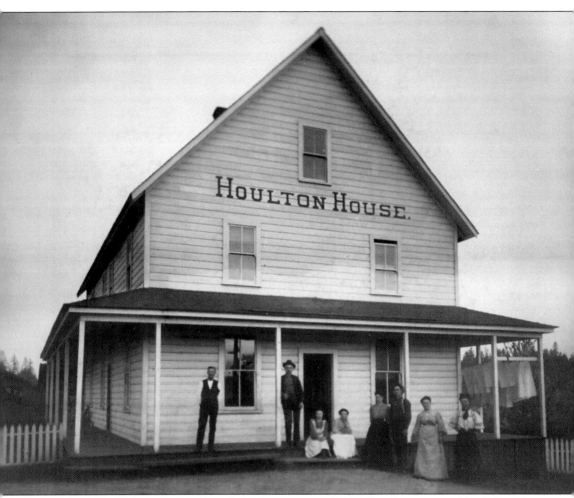

Houlton House, pictured here in about 1890, was a 16-room hotel constructed by G.D. Gilson. Travelers could leave their horses in the care of the livery stable next door. Later, the hotel was purchased by the Watkins family and, later still, renamed the Tourist Hotel.

Three

BUILDING ON BASALT

Explorer William Clark wrote about the rocky, gray cliffs that hemmed in the Columbia in his 1805 journal. The bane of builders and a boon to quarrymen, settlers would find formations of Columbia River basalt just inches below the topsoil. Created by multiple lava flows millions of years ago, these formations are the reason why most early farming was done outside of the city.

Portland resident Abigail Scott Duniway, a leader in Oregon's suffrage movement, was only half-joking when she said, "St. Helens . . . is the last place created by God on this earth, and it angered him, and he heaved rocks at it!"

Multiple quarries hauled out the columnar basalt, Belgian blocks, and crushed rock that were in demand and easily transported by barge. Skilled Italian and Polish tradesmen came to cut and lay block, and in 1906, St. Helens built the imposing basalt courthouse that is still in use today. On the opposite corner, the current city hall building housed the bank in 1908. A later addition allowed for more businesses along the plaza.

The hectic docks were stacked with lumber and lined with sailing ships—taking on loads for distant ports. The mills hummed with workers on every shift. Logs arrived from surrounding forests via company trains and flumes and were corralled into rafts and floated to the mills. Across the channel, two more mills and the ribs of wooden ships rose above the beach. In nearby Houlton, there were more lumber mills and the makers of barrel staves.

The late 1800s and early 1900s marked the rise of local entrepreneurship, led by can-do men who developed businesses strengthened by the additional resources and support of family. The wealthy industrialists were joined by the independents—a force of shopkeepers, bakers, barbers, butchers, and hoteliers who grounded the town. They sold dry goods, taught school, and practiced law. Fraternal organizations and churches met their social needs as well, fortifying them as they fought back against the floods and fires that struck the area.

This era marked the first industrial boom that made St. Helens a workingman's town.

Plymouth Congregational Church was built in 1897 along Columbia Boulevard. At left in this 1902 photograph is a pond that was a favorite place for winter or summer fun before it was filled in. The lot was donated by Hannah Tyszkiewicz, a major landholder in St. Helens. (Courtesy of Diane Dillard.)

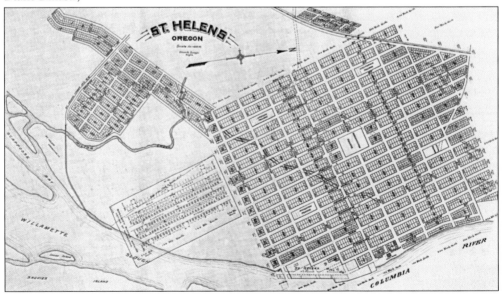

Peter W. Crawford and William H. Tappan surveyed and laid out St. Helens, and Joseph Trutch later mapped it. "Plymouth," as it was first called, was laid out in a simple grid that was confounded by topography. Streets dead-ended at basalt outcrops or ravines, requiring roundabout travel solutions. Later, Portland Road wove through town at an angle, further upsetting the surveyors' symmetry. (Courtesy of the City of St. Helens.)

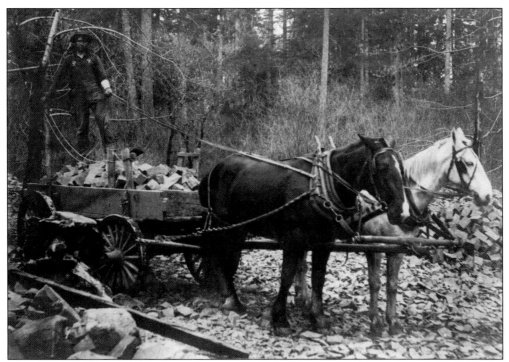

Tom Watters left school in the ninth grade and worked in the quarry after his father's early death. In 1908, the estate left a wagon and two horses—Jim and Dick—that were each worth $20. Watters hauled Belgian blocks from a quarry in the Grey Cliffs area of northern St. Helens to a Portland-bound barge. (Courtesy of Les Watters.)

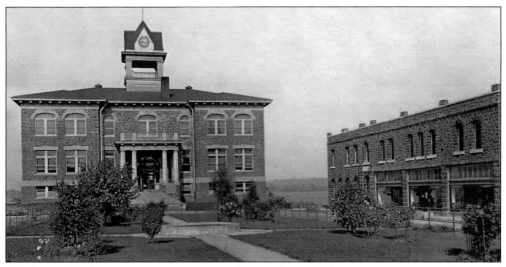

The first Columbia County court met in 1854 in Milton, which was county seat until it moved to St. Helens in 1857. The devastating blaze of 1904 spared the original wooden courthouse, but the danger was apparent. In 1906, the city leaders laid the cornerstone for a courthouse built from local basalt. The bell and the Seth Thomas clock in the tower were added in 1910. A modern courthouse annex was constructed in 1972.

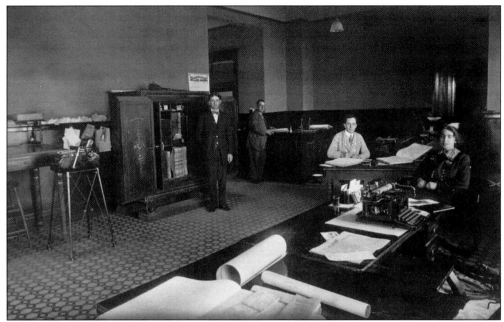

This photograph from the early 1900s shows the staff of the Columbia County Clerk's Office. They are, from left to right, A.F. Barnett, county clerk; Albert W. Mueller, attorney; H.E. La Bare, deputy clerk; and Bessie Hattan, treasurer. Hattan, the daughter of the late Judge Robert S. Hattan, was the first woman to hold office in the county. (Courtesy of the Anna Walker Collection.)

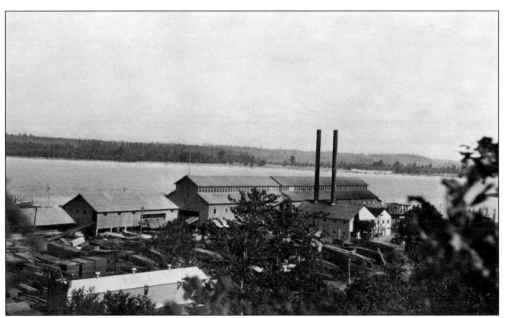

The Muckle Mill spread below the bluff and along the riverfront. It burned in 1904, opening the way for another entrepreneurial family to gain footing in St. Helens. The McCormick brothers bought the property, and when production began in 1909, workmen cut 125,000 feet of lumber in one 10-hour shift.

W.J. "James" Muckle owned a sawmill, store, and extensive timber holdings with his brother, Charles. After the fire, they entered real estate, buying the St. Helens Hotel and building the brick Muckle Building on the corner of Strand and Cowlitz Streets. The beautiful brick structure deteriorated over the last century, but the current owners are making repairs.

James's wife, Jennie G. Muckle, lived to age 70, passing away in 1930. James and Jennie's first son, James Kenneth Muckle, died at the age of one in 1884. Jennie was active in women's groups and activities that benefitted local charities. The Muckles and their son are buried at the Masonic Cemetery in Columbia County.

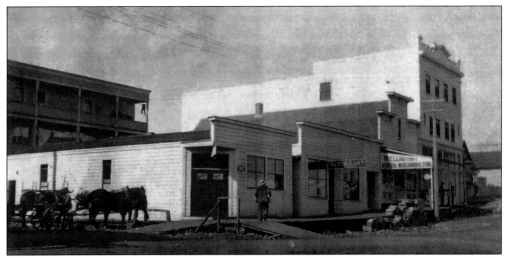

Thomas and Elizabeth Isbister came from Scotland's Orkney Islands to settle in St. Helens. The balcony of their boarding house is visible here at left. The couple would expand their property to absorb the corner business on Cowlitz Street and the Strand and add a second story, naming it the Orcadia Hotel.

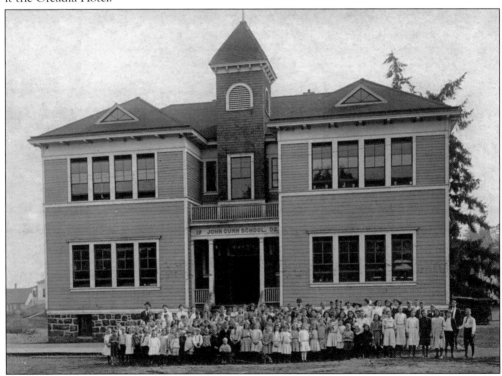

In 1883, John Gumm, a bachelor with no heirs, willed the proceeds from the sale of his land to fund schools in St. Helens and Columbia City. The original school opened in St. Helens in 1884, and was remodeled and expanded in 1911 before burning down in 1916. A new John Gumm School was constructed on the same site, opening three years later. It served grades 1–12 until 1926, grades 1–8 until 1958, and K–6 until its closure in 1999. Long ago, students would make an annual trip to decorate Gumm's grave on Germany (now Liberty) Hill. (Courtesy of Gayle Smith Harbison.)

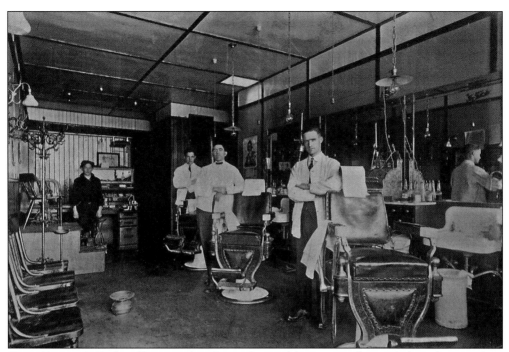

Harry Bennett's Barber Shop on First Street featured hot water, electric lights, three modern chairs, a shoeshine boy, and a spittoon. (Courtesy of the Bennett Family.)

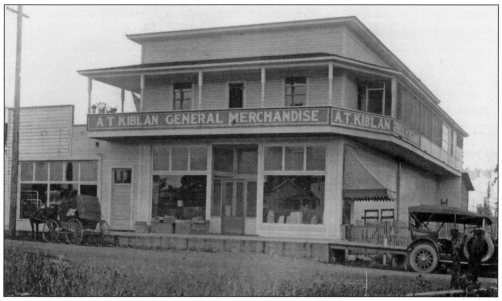

A.T. Kiblan founded Kiblan's Dry Goods and Clothing on Columbia Boulevard in 1914, with T.J. Kiblan taking over in 1929. The family lived above the Houlton store. One family member recalled, "When Grandpa Kiblan built the first store . . . the local businessmen, all of which were located in St. Helens [now Old Town], kidded A.T. Kiblan, telling him he didn't know where the town was. His reply was that the town would move up to the railroad, which it did." (Courtesy of Mary and Malea Kiblan.)

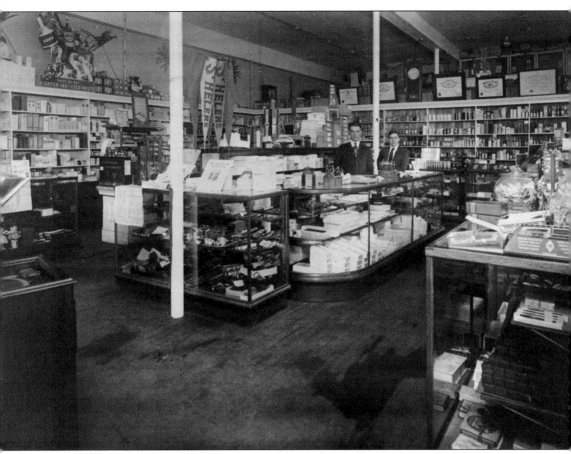

Alphonso J. "Jay" Deming ran a drug store in Independence, Oregon, before relocating to St. Helens with his wife, Lena, to set up shop and raise their family. In this photograph, Deming and A.T. Laws are ready to help customers with general retail items or prescriptions at Deming's Drug Store inside the Muckle Building. Deming's sons followed in his footsteps and joined the pharmaceutical field. (Courtesy of the Deming Family Collection.)

Abraham Crouse and his family were loggers who first lived in Yankton (possibly derived from "Yankeetown," for the number of northeasterners who lived there). Later, the Crouses bought land in Houlton and lived where the landmark redwood tree stands today. Abraham was the father of 16 children. (Courtesy of Gayle Smith Harbison.)

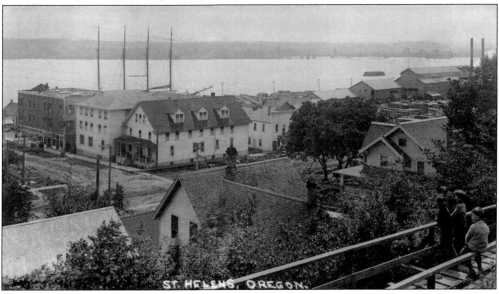

Young boys peer down at their town from Nob Hill. The St. Helens Hotel is at center. In 1904, the *Mist* announced, "Jas. Muckle . . . has informed us that he was about to let the contract to a man to move the large opera house building from its present site to the corner formerly occupied by A. King's blacksmith Shop, where it will be remodeled and made into a two-story hotel." By 1908, the hotel was overflowing, so Charles Muckle built a three-story annex. The hotel was torn down, but today, the annex is the Klondike Restaurant and Bar.

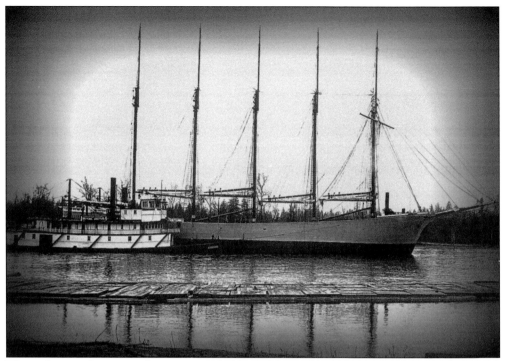

The early waterfront was a busy port, with ships taking on lumber, spars, rock, and other cargo. Stern-wheel tugs, such as the *Cascades* at left, helped position the sailing ships at the docks.

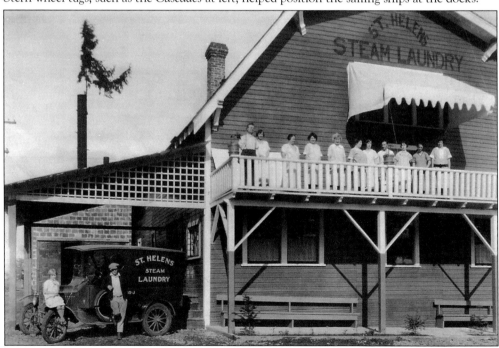

Gerald Wicks—seen standing with his truck—worked with his wife, Daisy Ryan Wicks, and his mother, Barbara Wicks Robertson, at the St. Helens Steam Laundry. This long-running business was situated at Third Street and Columbia Boulevard. (Courtesy of the Wicks Family.)

Robert Dale Perry poses for a fun photo. Some 200 customers relied on the St. Helens Dairy, operated by S.N. Cade, for sterilized milk processed at his cold-storage plant. Cade delivered and sold milk through two grocery stores, where his product was kept on ice. Along with milk, he also sold farm-fresh fruit and vegetables. (Courtesy of the Perry Family Collection.)

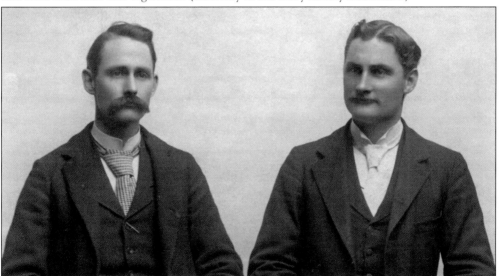

Several Ross family members left their marks on St. Helens history. Pictured at left is Dr. Edwin Ross, who came to town as a pharmacist and operated a drug store while attending medical school in Portland. Upon graduating in 1894, he entered practice. He married Matilda Muckle—niece of Charles and James—in 1903. Meanwhile, Adin Ross (right) ran a business on the plaza that advertised "Undertaking - Embalming - Complete Home Furnishings."

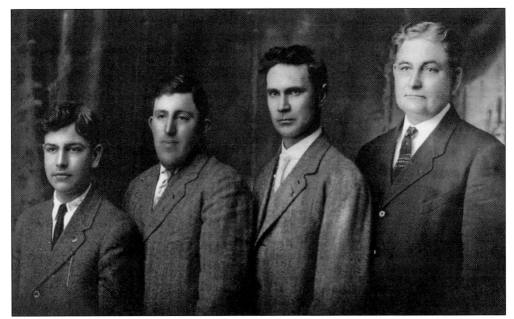

Columbia County Bank founder William Ross, far right, gathered his sons for this portrait. From left to right are Cecil Ross, who became a physician; Harold Ross, who died of influenza during World War I; and Levi "L.G." Ross, who studied medicine and served the county's public health needs for decades. He eventually established the area's first hospital. (Courtesy of the Ross Family Collection.)

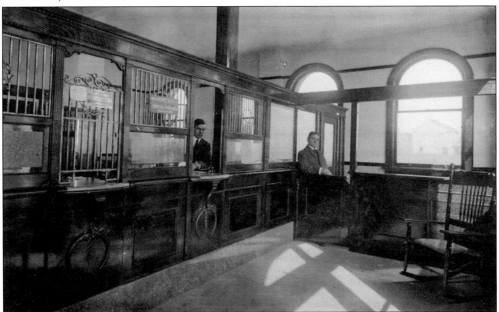

William M. Ross (right) founded the first bank with his brother, Edwin. Pictured in the pay window is Albert "Bert" Stone, Ross's son-in-law. The bank building, constructed from local basalt in 1908, comprised the eastern third of what is now City Hall. The building was expanded to include law and doctors' offices, a drug store, a custom wood furniture and cabinetry shop, and mortuary services—all Ross family enterprises. (Courtesy of Verlene Ross.)

The elaborate Cliff House on South First Street was built in 1905. The Cliffs lived there for three years before moving to Portland. The home is most often associated with the second owners, Dr. L.G. and Verna E. Ross. Shown here in 1910 are Cecil Ross (left) and Iro Barker. (Courtesy of Verlene Ross.)

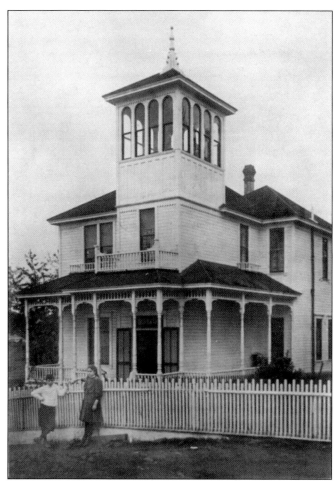

This 1920s photograph of downtown St. Helens shows First Street and the Kaleva Hotel in the foreground. The large St. Helens Hotel is at center, and the McCormick offices are to its right. The iconic basalt courthouse was built between 1906 and 1908. The waterfront did not include the landmark Sand Island—now a marine park—until pumped river dredgings accumulated over the years. In 1921, the US Army Corps of Engineers recommended creating a 300-foot-wide channel that was up to 30 feet deep at low tide.

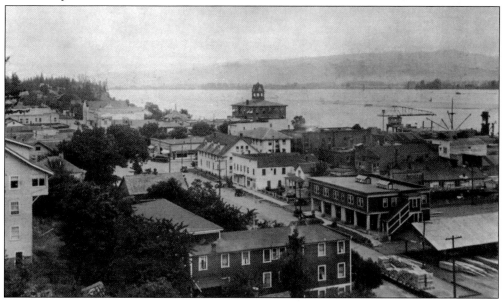

Charles McCormick, pictured here, and his brother Hamlin were bachelors when they arrived in St. Helens in 1908, to "look over" the community as a business prospect. They purchased the site of the burned Muckle Mill, thereby founding a St. Helens industrial empire that included timber, shipbuilding, a creosote plant, a lumber company, and a pulp and paper mill. (Courtesy of the McCormick/Perkins Collection.)

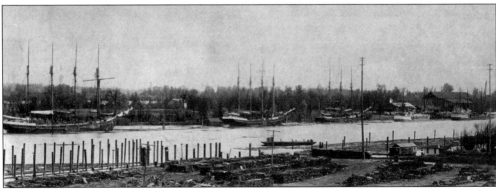

Across from St. Helens, on the northern tip of Sauvie Island, were the St. Helens Shipbuilding Company and two mills—all owned by the McCormicks. Everything they touched was profitable, it seemed. Employing hundreds of workers, the shipyard launched the *Multonomah* in 1912, followed by steam schooners *Merced*, *Celilo*, *Wapama*, and *Everett*.

Workers at the Sauvie Island shipyard pause for a photograph. Charles R. McCormick and Company was headquartered in San Francisco, while Hamlin remained in St. Helens with his wife, Nellie. The McCormicks held a 15-year reign over the shipbuilding industry before that arm of their business began a slow downturn. (Courtesy of the McCormick/Perkins Collection.)

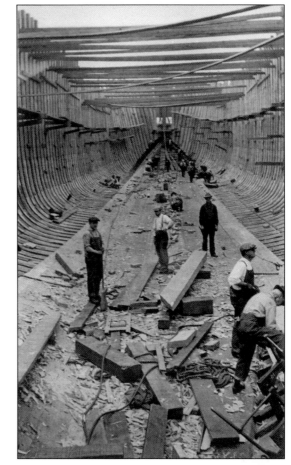

During the boom years of the mills and shipyard, boarding houses and hotels were home to bachelor workmen. The Kaleva Hotel offered 75 rooms for boarders. Remnants of the foundation can still be found on the empty lot south of the Dockside Restaurant on First Street. (Courtesy of the Mary Colvin Collection.)

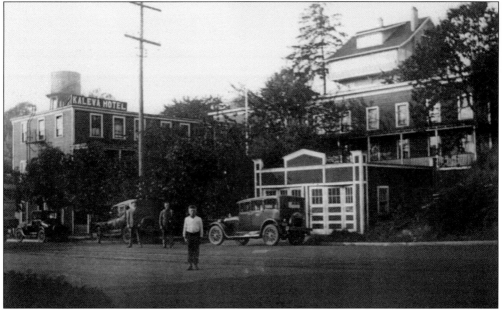

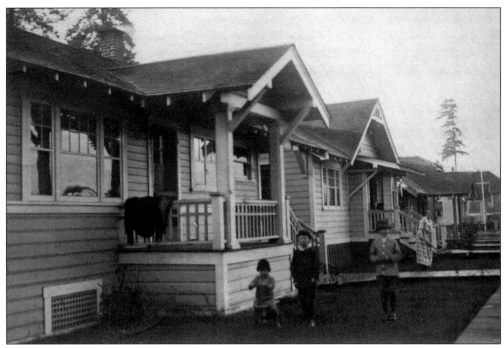

Housing shortages created a building spree in 1918. Two arms of the McCormick businesses were contracted to build 25 houses in "Bungalow Park," each costing from $1,365 to $2,524. The homes, many of which still line South Fourth Street and Park Way, had indoor plumbing and electric lights. The Perry family was among the new homeowners. (Courtesy of the Perry Family Collection.)

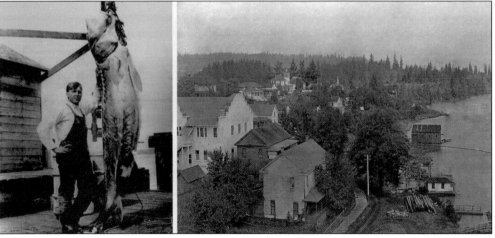

Photographer E.C. Laws captured the image at left of a 700-pound sturgeon caught in a gill net near St. Helens in 1910. When commercial fishermen brought in a 225-pound sturgeon 40 years later, Laws went back to his archives to reprint this photograph in the *Sentinel-Mist*. To the right are the Lemont and Durrell homes—built in 1851 of lumber from Bath, Maine. They were razed in the early 1970s to make room for a parking lot by the new courthouse annex. Behind them is the old city hall, which once housed fire department equipment, the library, city offices, the *Sentinel-Mist*, and community rooms. US National Bank was later built on that corner. (Courtesy of the LeMont Family.)

Four

GETTING AROUND, STAYING IN TOUCH

In July 1851, Nathaniel Crosby and Thomas Smith published a newspaper advertisement boasting about Milton's fertile surroundings and its location on "the lower point upon the River that has a wagon road leading to the Willamette Valley."

St. Helens's first highway, however, was the Columbia itself. All manner of vessels traveled the river daily, while on shore, travelers on foot, horseback, and wagon used ancient Indian trails. Loggers also cleared routes for their ox-drawn carts, flumes, and steam donkeys. Most of these would eventually be incorporated into the road system.

The Northern Pacific Railway first offered a local route through St. Helens in September 1883. Proper service began in October 1884, when Northern Pacific made the final link from Minnesota to Portland and Tacoma: a rail ferry between Hunters (moved to Goble in 1890) and Kalama, Washington. The ferry was discontinued in 1908 when the railroad opened a line from Kalama to Portland on the Washington side, leasing the tracks to the Astoria and Columbia River Railroad.

Milton hosted a station as far back as 1892, but it was closed by the time floods destroyed the town. By 1905, rail patrons were angry about shipment delays because they lacked a station agent, so Northern Pacific built a depot in Houlton. It burned in 1920, but within a year, a new building across the tracks opened. It served the area until 1996, when the Portland and Western Railroad took over the line. The depot also acted as a commercial Western Union Telegraph office as well as a Railway Express Agency.

Local road grading began in 1915 and 1916, funded by county bond issues. The state then paid for grading and macadamizing the highway. In 1919 and 1920, the concrete bridge over Milton Creek was constructed, and the entire 55.6 miles of the Columbia River Highway that passed through the county (now Route 30) were graded to state standards and paved.

According to the state, the route from Astoria to the Hood River was now complete: "The trip down the Lower Columbia River Highway, which in the winter was formerly a matter of uncertainty, may now be made in a very few hours."

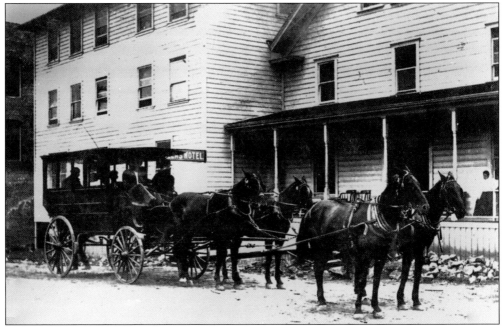

In 1910, the stagecoach stopped for passengers at the St. Helens Hotel, on the corner of First and Cowlitz Streets. Stages were commonly used for connecting passengers with steamships and trains.

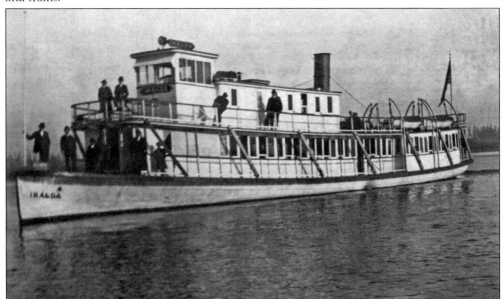

The *Iralda* transported passengers and cargo between St. Helens and Portland for years—including a literal "milk run," in which she carried dairy products from downriver farms. Supposedly, the steamer also took shanghaied men from Portland to the coast, transporting men kidnapped into a seaman's life. The *Iralda* also may have decided the fate of the county seat in the 1903 runoff election between Rainier and St. Helens. Locals heard of Rainier's plan to bring the *Iralda*'s crew ashore to vote in their favor. Instead, they were urged to disembark in St. Helens to vote, eat heartily, and stay until after the polls closed. (Courtesy of the *Portland Morning Oregonian*.)

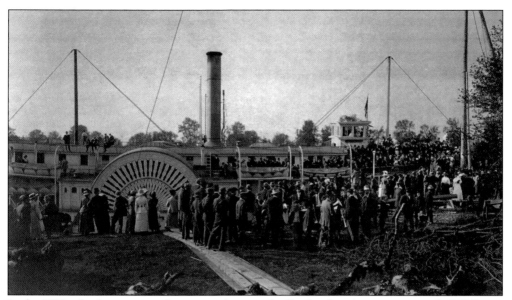

In the 1890s, the fastest, most elegant riverboat on the Portland-to-Astoria run was the *T.J. Potter*. "A grand piano encased in bird's-eye maple, a paneled dining saloon, tables set with linen and silver, and a cuisine that rivaled any of Portland's finer restaurants made travel a pleasure," wrote one maritime historian. Later, the side-wheeler was lengthened, and the wheelhouse was topped with a dome. Abandoned in 1921, the ribs of the *Potter* are still visible on the northeast shore of Young's Bay in Astoria. (Courtesy of the McCormick/Perkins Collection.)

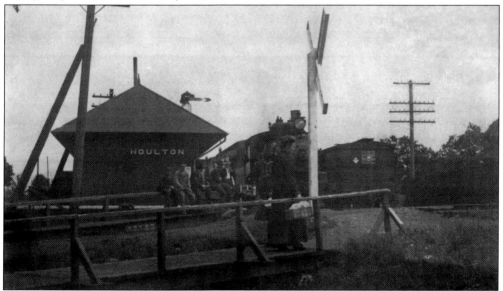

"Houlton had the rail; St. Helens had the sail," a writer once quipped. In 1883, Henry Villard built the main line of the Northern Pacific out of Portland, through Columbia County, and as far out as Hunter's and, in 1890, to Goble. Then in 1898, the Astoria and Columbia River extended from Goble to Astoria. The Houlton depot was on the west side of the tracks. Here, Dora Crouse Smith stands with her great-niece Marjorie Billeter. The newer St. Helens depot, built in 1921 on the opposite side of the railroad tracks, is now occupied by the South County Chamber of Commerce.

On February 7, 1911, the city bought three and a half acres on North Fourth Street from J.B. Godfrey for $2,200. Godfrey Park was the site for many family picnics, ball games, and community gatherings, such as the annual Easter egg hunt. The tree-studded park is still a favorite, with picnic tables, a playground, and horseshoe pits. (Courtesy of the Francis Anderson Collection.)

The St. Helens Fourth of July celebration in 1915 was well attended. The old courthouse steps provided a vantage for viewing the St. Helens Band in the plaza below. Note the old Columbia Theatre with its vertical sign in the background on the left.

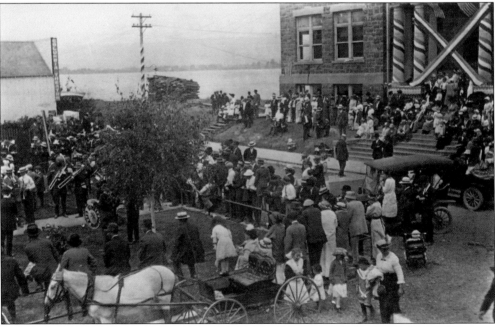

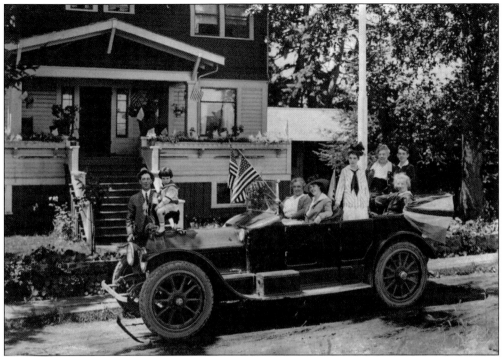

The Swepson Morton party prepares to join the 1915 Fourth of July celebration. Born in Georgia in 1879, Morton settled here with his wife, Therese, in 1909—serving as auditor for the Charles R. McCormick Lumber Company. Their home was next to the McCormick house on Nob Hill. After resigning in 1916, Morton bought the *St. Helens Mist* and ran it for a decade. He also served as mayor, city council member, and county judge, and helped found the Chamber of Commerce.

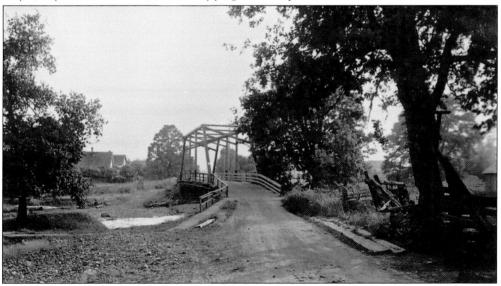

The bridge over Milton Creek was a country road in the early 1900s. Today, this crossing is next to Ace Hardware on Columbia Boulevard. In 1914, Houlton voted to join St. Helens, and was called West St. Helens until business growth near the tracks and highway created the term "Uptown" for the Houlton area, versus "Downtown" for old St. Helens.

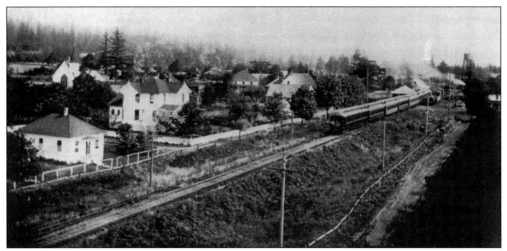

A northbound Spokane, Portland, and Seattle Railway passenger train pauses in Houlton. The Astoria and Columbia River Railroad was purchased by the James J. Hill interests in 1907 and, in 1911, was turned over to their new SP&S Railway, which assumed the Northern Pacific's Goble-Portland line. SP&S operated the entire line between Portland and Astoria until the Burlington Northern rail merger of 1970.

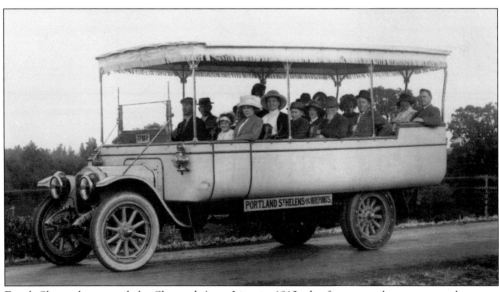

Frank Shepard operated the Shepard Auto Line in 1913, the first motorbus company between St. Helens and Portland. Frank's brother, Capt. Orin Shepard, joined him in 1914. The brothers made two trips to Portland daily. Orin had been skipper of the *America* for 13 years. He returned to the river and founded the Shepard Towing Company, which he owned until his death.

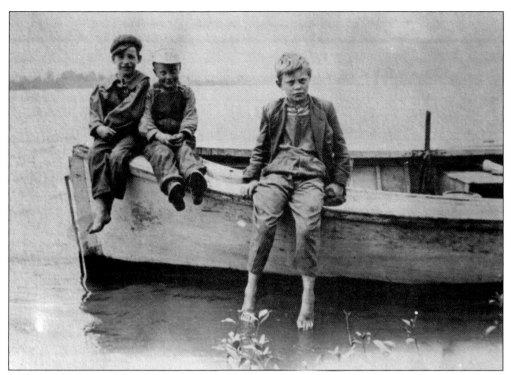

In this 1922 photograph, a youngster treats his toes to a dip in the river, while smaller boys balance on the bow. The boy wearing shoes is Fred Watters.

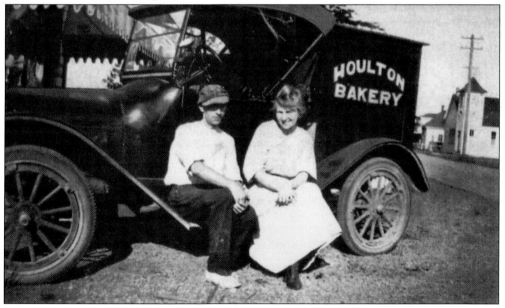

Born in 1891 in Bavaria, Sebastian "Heinie" Heumann (left) was a self-employed baker in Houlton. His wife, Hilda Morten (right), was a Swedish immigrant. Heumann registered for the draft in both world wars, and was stung by the loss of some regular customers during World War I. Afterward, he joined the Fourth of July parade, proudly driving a car decked out in red, white, and blue. The city named a small park for him, near the senior center. (Courtesy of Joyce Heumann Heller.)

Here, Max R. Oberdorfer and family enjoy a day at the beach in Seaside, Oregon. From left to right are Gerta, Helene, Max Jr., Carl, and Max Sr. In 1925, Oberdorfer and Willard P. Hawley began plans to establish the St. Helens Pulp and Paper Company, adding hundreds of jobs to the local economy. The Hawleys were already operating a similar company in Oregon City. (Courtesy of Diane Dillard.)

George Perry applied some fun graffiti to his 1925 Model T roadster. Perry returned to St. Helens after World War II. He was among a group of prisoners of war who had to find their way to other Americans at war's end, after the enemy abandoned their POW camp. (Courtesy of the Perry Family Collection.)

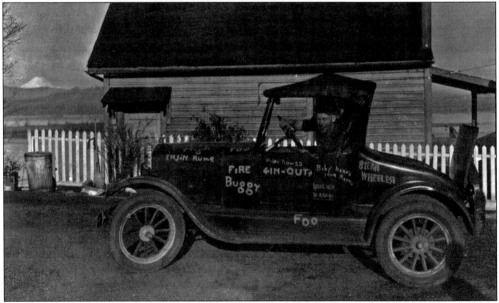

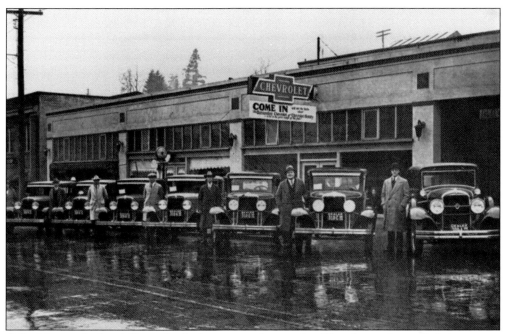

Gilby Motors, the local Chevrolet dealer, occupied a stretch of First Street that included a passage to the garage with a sign to "Blow Your Horn" for entry. In this photograph, a group of Chevy dealers have met in St. Helens. (Courtesy of the Don L. Kalberer Collection.)

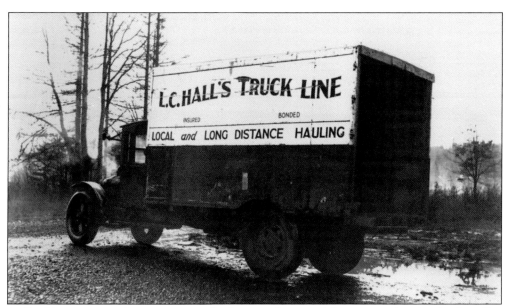

Molloy Transportation began in 1911 with a horse and wagon, delivering goods to Portland. Molloy replaced the horse with a truck and then sold out to L.C. Hall. Hall expanded to a fleet of trucks, and the business still serves the county to this day. (Courtesy of the Hall Family Collection.)

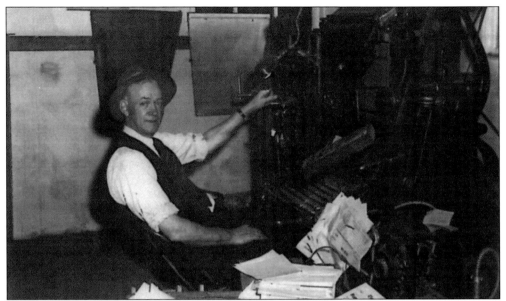

Paul S. Paulson is shown here at work on his linotype. In 1936, Paulson started *The St. Helens Chronicle* as a single-sheet newspaper, competing with the older *St. Helens Sentinel-Mist* by distributing a free hand-typeset sheet three times a week. In the 1950s, Paulson's paper expanded into a traditional broadsheet format and published twice weekly. The two newspapers merged in 1968, creating the *St. Helens Sentinel–Mist Chronicle*, known as the *Chronicle*. (Courtesy of the Paulson family.)

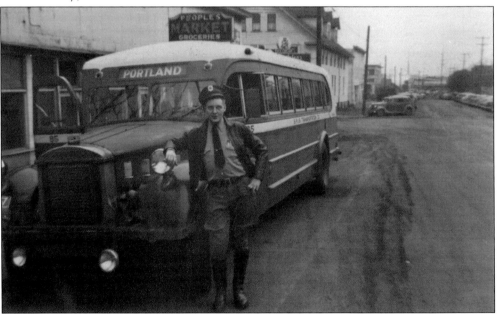

Larry Jensen poses outside the bus depot in 1938. This corner would one day be the location of the St. Helens Cafe and, later, the Plantation. At age 18, Jensen drove between Portland and Astoria for no pay until he was licensed. After graduation, he drove for the Spokane, Portland, and Seattle route, and then for Oregon Motors until 1948. In 1956, Jensen bought the local school bus company. (Courtesy of the Jensen Family Collection.)

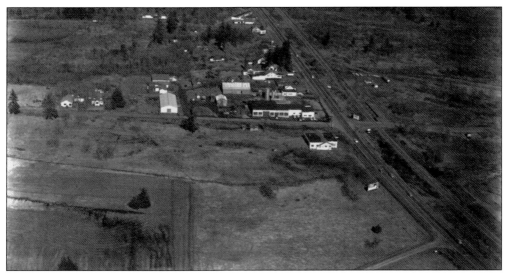

The intersection of Columbia River Highway and Gable Road is visible in this aerial view from the 1940s. The standalone building on the corner was the popular Sportsman's Inn, now the site of U.S. Bank. The current high school would be built on the field to the west. (Courtesy of CPS.)

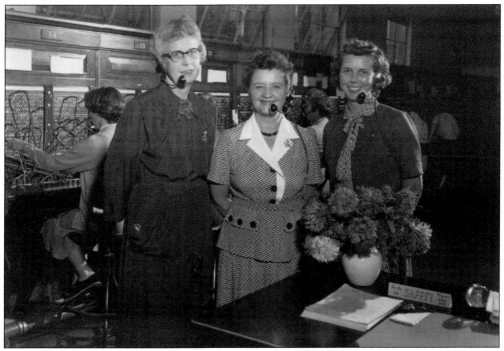

Telephone operators of the early 1950s worked on a bank of switchboards in this downtown office. Three women of the staff are pictured here, including, at right, Mabel Pennell. (Courtesy of Naomi Larson Brown.)

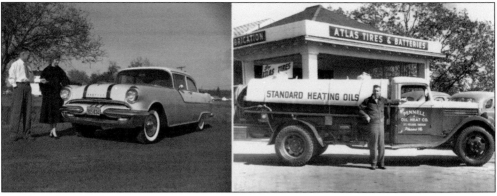

At left, Jack Keudell, a local car dealer, hands Elaine Haling Lease the keys to a new 1955 Pontiac with whitewall tires. For young married couple Ron and Elaine Lease, this would be their first car. At right, Lee Pennell's service station stood at the corner of First and St. Helens Streets, where condominiums were built in the mid-1990s. He sold gas, oil, batteries, tires, and car accessories, and offered repairs and home heating oil delivery. Pennell is remembered for the many ways he served his city. (Left, courtesy of CPS; right, courtesy of the Don L. Kalberer Collection.)

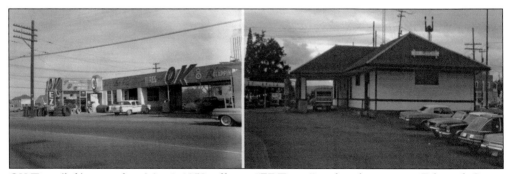

OK Tires (left) opened on May 1, 1958, offering "EZ Terms" at their location on Fifteenth Street and Columbia Boulevard. Owner Myri Bush moved from Longview to open the business. The railroad depot (right), which opened on November 25, 1921, saw decades of use before Burlington Northern closed it in 1996. The Willamette and Pacific Railroad later leased the line, and the building currently serves as headquarters for the South Columbia County Chamber of Commerce. (Left, courtesy of CPS; right, courtesy of the Dave Sprau Collection.)

Five

SOCIETY BLOOMS

In time, frontier towns have their rough edges knocked off, usually by women. Early families sought the pleasures of theater, music, and art, and the kinship of church and fraternal gatherings.

Missionaries like Thomas Condon were the first to see to the spiritual needs of the pioneers, and simple church buildings sprang up. Similarly, some of the first waterfront structures housed social organizations like the Odd Fellows, Masons, Rebekah Lodge, and Knights of Pythias. Teas, birthday parties, and holiday gatherings drew ladies in their mud-sweeping skirts, and gents in three-piece suits and top hats.

Early theatergoers could enjoy a performance or a "photo-play" at the Roxy, the Gem, the Liberty, or the Strand. In 1927, G.O. Garrison arrived and bought two local theaters, but wanted better for his customers. A year later, he opened the new, 700-seat Columbia Theatre, advertising "the most modern apparatus and appointments."

Community-wide celebrations, such as voting day in August 1903, were often cause for a big feed: "the women of the town gave their famous all-day dinner in the lower part of the old Masonic hall," reported the *Sentinel-Mist*, "where huge roasts, hundreds of biscuits, scores of pies and cakes and wash boilers of beans, all provided by the Muckle Bros., and cooked by the women, were served to voters."

For the laying of the courthouse cornerstone in spring 1906, St. Helens threw open its doors. Nearly 1,500 people came to town, including 200 who rode the Northern Pacific to Houlton from Portland, Scappoose, and Warren. The Astoria and Columbia Railroad delivered passengers from northern river towns, and a Portland steamer arrived bearing the 16-piece band, the governor, and other prominent citizens. After music and speeches, a vast table was set for 600 diners—their chairs filled as soon as they finished. The solemn ceremony by the Masons followed, and water sports, boat races, and two dances completed the great day.

The county fair, opera, basketball and baseball games, Fourth of July parties, weddings, dances, parades, and funerals—St. Helens society found its rhythm. That warm spirit of community is just as alive today.

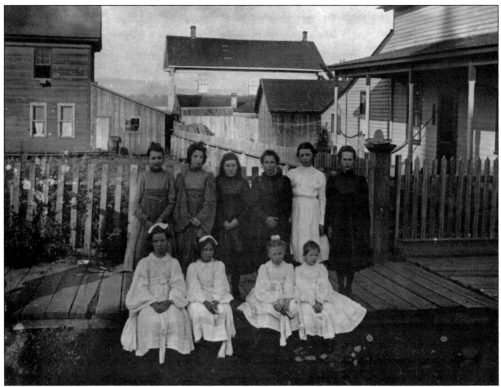

Posing on the boardwalk by the W.A. Harris and A.J. Deming houses, these partiers are dressed in their Sunday best. They are identified as Ida George, Alice Quick, Anna Quick, Bessie Hattan, Sadie Ellis, Edna Harris, Lena Lindsay, Hazel Watts, Ruth Richardson, and Hilda Cliff.

The Rosasco, Valpiani, Corsiglia, Romiti, Caniparoli, and Pasero families are gathered here for the 1912 opening of the Italian Importing Company on North Fourteenth Street. The expansive, multi-storied grocery business stood between Columbia Boulevard and St. Helens Street for decades. Many local Italian families formed a community to retain their culture and language.

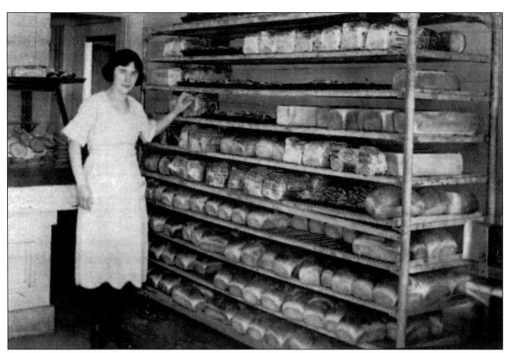

In the 1920s, with the Houlton Bakery making and delivering its own brand—Heinie's Bread—local women no longer had to slave over their hot ovens. Pictured is Ethel Ketcham, who lived and worked with Heinie and Hilda Heumann. (Courtesy of Joyce Heumann Heller.)

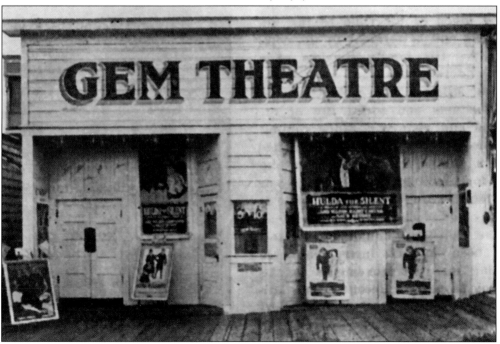

The Gem featured "elevating and instructive" silent films accompanied by pianist Bertha Woods. *Hulda the Silent*, advertised here, was released on May 20, 1916. The Liberty owners bought the Gem in March 1919. Later, it was a car salesroom and, later still, a dining room for the Orcadia Hotel.

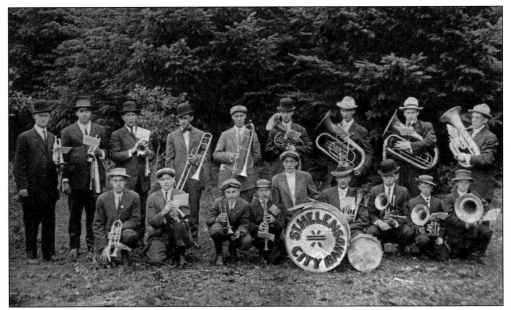

The St. Helens City Band advertised for new members in the *St. Helens Mist*. The range of ages seen here suggests that the elders were encouraging young members. The band played for ship launchings, lodge events, Fourth of July gatherings, the county fair, and anything else that required a bit of flair.

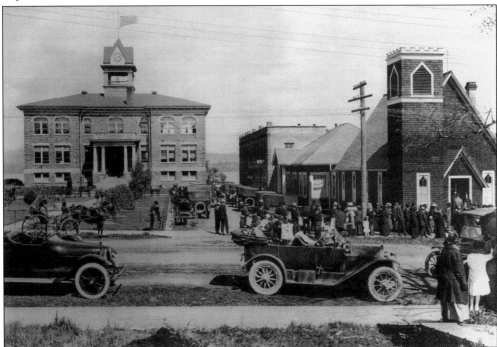

The July 11, 1912, funeral of the respected Eliza Muckle Switzer, 67, drew crowds. Christ Episcopal Church was built on a lot donated by Hannah Tyszkiewicz and James and Charles Muckle. A.H. George framed the building in 1897. A bell tower was added in 1907. Behind it stands the Ladies' Guild Hall. The building now houses the Pieper-Ramsdell Insurance Agency.

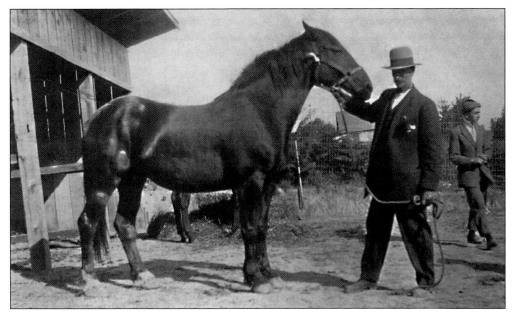

Here, George H. Lemont shows his prize mare at the Columbia County Fair. The first fair was held at the Yankton Grange Hall in 1908. It then moved to Washington Square (site of Lewis and Clark Elementary), then to Deer Island, and finally, to its current location. George's father was first mate on the *Comet* and died in San Francisco in 1863. In 1850, George's uncle Capt. Francis A. Lemont settled in St. Helens at age 37. He ran a store and put up salt salmon in Jamaica rum barrels for shipment to Hawaii and the Orient. (Courtesy of the LeMont Family Collection)

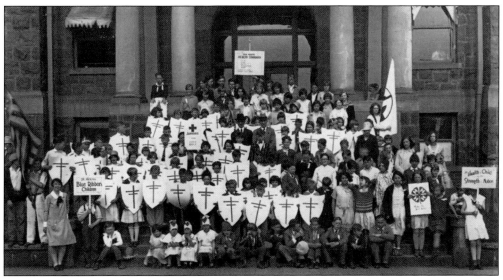

Public Health nurse Nettie Alley, at left with black tie, organized Child Health Day on May 1, 1929. Children who had "all defects corrected" (dental exams and shots) received a blue ribbon. The children also engaged in a health parade, maypole ceremony, and drills in the plaza. Alley oversaw 50 small schools, five larger ones, and five high schools, fighting against "itch mite," whooping cough, impetigo, and tuberculosis, and encouraging vaccinations against diphtheria and smallpox.

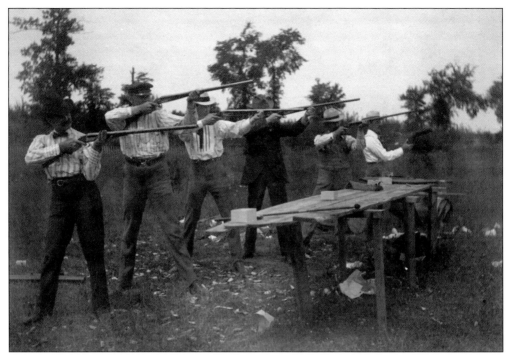

In a 1916 report, Deputy Game Warden William Brown wrote of various gun clubs' assistance in keeping birds and game alive during a record-snow winter. "They not only labored industriously, but put up money to purchase wheat and conveyances to feed the birds." Brown especially credited Oscar Anderson of Rainier and Swepson Morton Sr. and Clyde Sutherland of St. Helens.

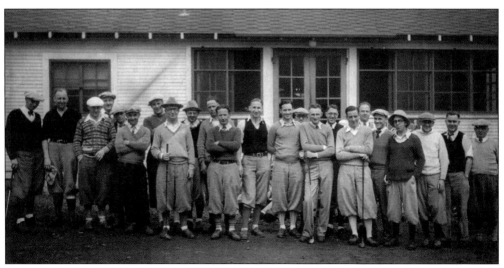

Sportsmen of all stripes balanced work with play. The greens of the St. Helens Golf Course were once located near the intersection of Gable Road and Highway 30, where Firlok Park Homes and today's high school were built decades later. (Courtesy of Doug Morten.)

Liberty Inn, on the corner of Pittsburg Road and Highway 30, offered meals, rooms with a view, and opportunities for tourists to be photographed with Lady Liberty.

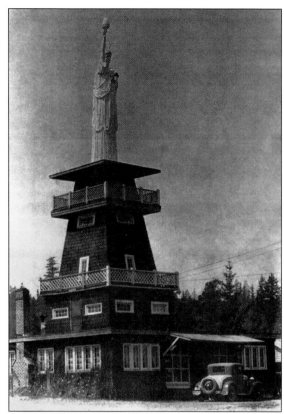

John Gumm's 1938 championship basketball team was undefeated in 21 games. From left to right are (first row) Peter Milne, Lynn Hall, George Guentner, James Brock, unidentified, David Ostlund, and Eldridge Crouse; (second row) manager Dean Mason, Bob Hiatt, Wallace Bronson, Richard Hamilton, and coach Pat Cody. (Courtesy of Sharon Cody Marsh.)

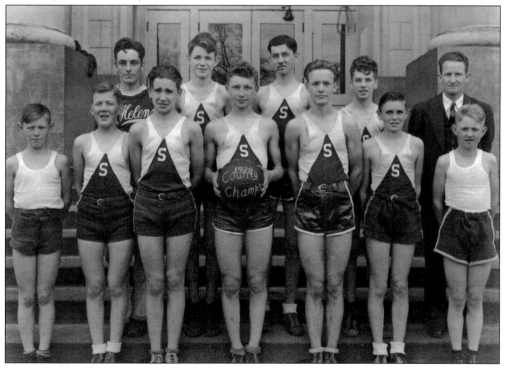

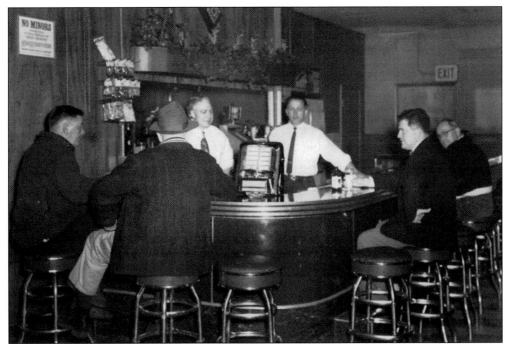

The Kozy Korner has been a favorite restaurant and watering hole for years. Pictured behind the bar are owners Olaf Matson (left) and John Beck. In 1960, the restaurant was expanded and remodeled by well-known architect Lewis Crutcher. (Courtesy of Frieda Matson Ryland.)

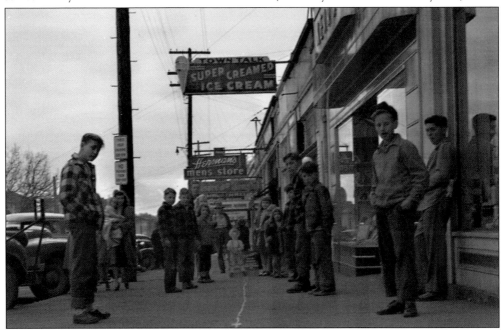

In downtown St. Helens, First Street was the place to find your friends. The Town Talk, next to Kerr's Variety Store on South First Street, advertised "Super Creamed" ice cream. Clothing shops, drug stores, theaters, the bus depot, and several car dealerships kept downtown hopping in the 1940s. (Courtesy of CPS.)

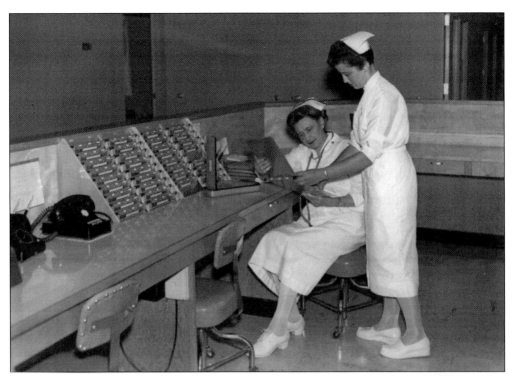

Registered nurses Lila Kerr (left) and Lorna White Bradley review a patient chart. The 35-bed St. Helens District Hospital opened in June 1956 and was equipped with a modern surgery, three registered nurses per shift, and an innovative floor plan. The St. Helens Civic League is credited with driving the effort to build the hospital—now the site of Legacy Urgent Care. An earlier hospital, founded by Dr. L.G. Ross, once stood on Fourth Street across from Godfrey Park.

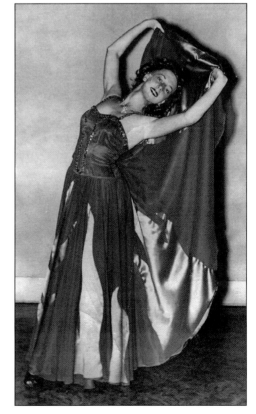

Elaine Haling was both Miss Flame and Miss Columbia County in 1948. She taught dance early in life, running her studio out of the basement of her mother's home. By the eighth grade, she had 20 pupils. (Courtesy of the Elaine Haling Lease Collection.)

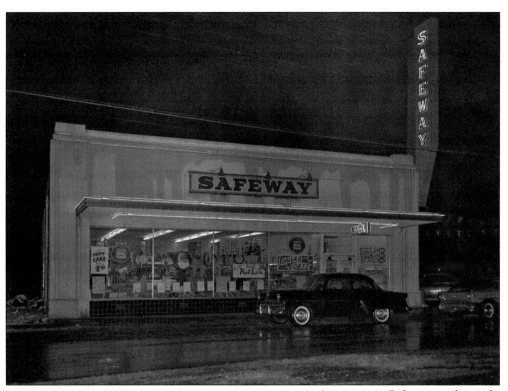

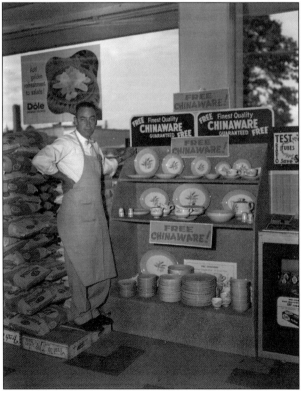

At one time, Safeway was located in the building that now houses the US Post Office. As it grew, the grocery store moved to a larger site along Milton Creek, and then to Gable Road and Highway 30. Thomas Food Center and Thriftway also were popular grocery stores. (Courtesy of CPS.)

Grocer Royal Thomas saw to it that many St. Helens families ate off identical china. His free dinnerware offer was a purchase incentive at the Thomas Food Center. (Courtesy of CPS.)

In this 1950 photograph, the old McBride School is visible behind the construction site of the new school on Highway 30. Several classrooms burned in a three-alarm fire on March 11, 1991. The 450 children were evacuated safely. The current incarnation of McBride Elementary is about a mile away.

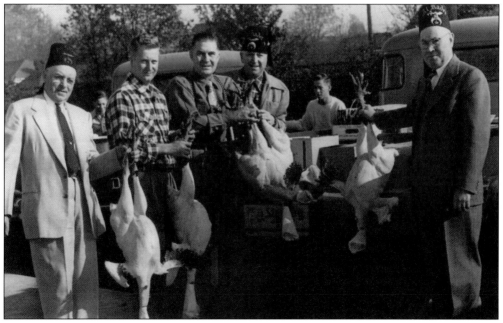

Each November, the Shriners, the Masons, and the Safeway store teamed up to deliver turkeys to families at the Shriners Crippled Children's Hospital in Portland. Their philanthropy continues today, in the form of a check for Doernbecher Children's Hospital. In the foreground, from left to right, are Mayor Heinie Heumann, Delmar Johnson, the Safeway manager, an unidentified man, and Gene Branan. Les Ross is visible between the trucks in the background. (Courtesy of SHPL.)

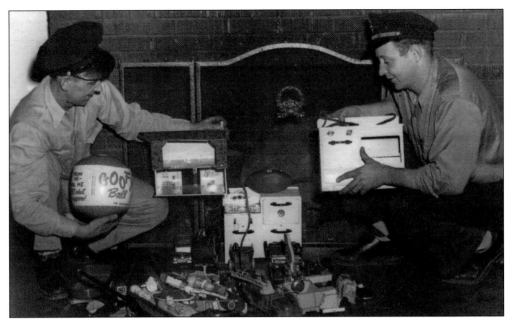

The fire department's Toy and Joy program has gathered Christmas presents for needy children for decades. Here, Jim Wellington (right) sorts toys with another man. In 1983, Dan May and other volunteers added an annual fundraising gala—with silent and oral auctions—to the program. (Courtesy of SHPL.)

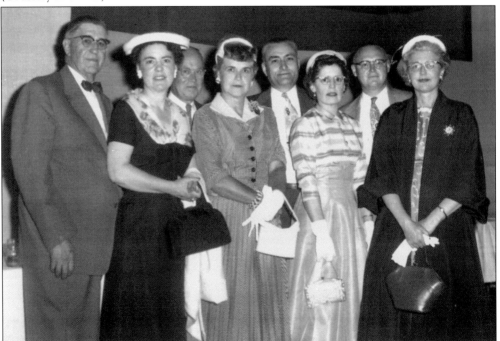

Bank of St. Helens executives and their wives stepped out for a special dinner in 1957. From left to right are president Joe Fisher and his wife, Barbara; manager Herb Johns and his wife, Doris; assistant manager Bert Wolfe and his wife, Olive; and head teller Paul Kruggel and his wife, Marietta. (Courtesy of Rhoda Wolfe Collier.)

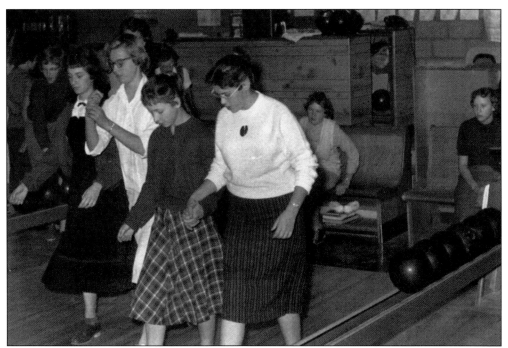

Teens took bowling lessons at Columbia Lanes as part of the high school's physical education program. Columbia Lanes was located in West St. Helens, off Columbia Boulevard. A group of businessmen also established Oregon Trail Lanes on Highway 30. (Courtesy of Sandy Cagle Fox.)

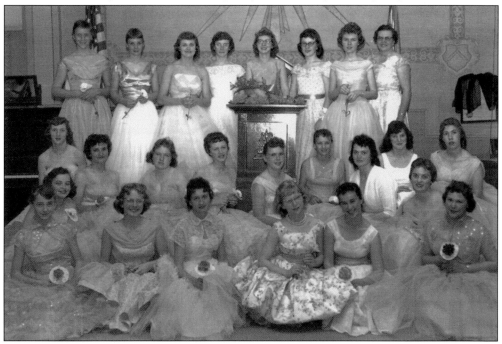

The International Order of the Rainbow for Girls, or "Rainbow Girls," is part of the Masonic organization. Aimed at encouraging leadership through community service, the group was popular in the early 1950s. (Courtesy of Sandy Cagle Fox.)

Carl Brandenfels Enterprises' hair and scalp applications were popular products, and when Brandenfels expanded to sales of holly, the post office relocated to handle increased shipments. The sheer volume of mail made St. Helens a major postal center, partially due to Brandenfels. (Courtesy of Peggy Tarbell and Stan Mallory.)

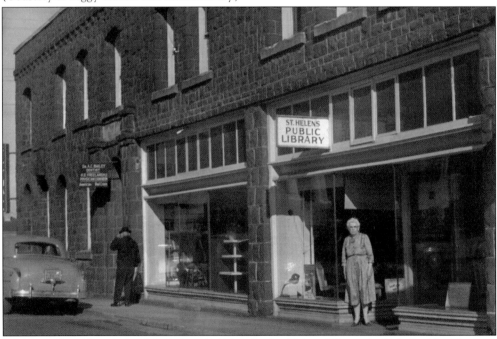

The city's first library was founded in 1914 by the St. Helens Woman's Club. Led by Florence Farnsworth, the ladies loaned their books, volunteered time, and conjured creative fundraising ideas. After Farnsworth's death, her books were donated. The library was then a room in the old City Hall, at First and St. Helens Streets. It moved in 1937 to what are now the City Council chambers, facing the plaza. Pictured is librarian Faye Hamilton, who taught English at the high school.

Six

ORDER AND DISORDER

Travelers on the Oregon Trail carried with them the moral code of "an eye for an eye." A murder on the trail resulted in the selection of a judge and jury, followed by swift justice in the form of hanging—with the perpetrator occasionally buried aside his victim.

Life on the river and in logging camps was rough and disorderly, and lawmakers were spread thin. In the newly formed St. Helens, citizens selected fair-thinking men as judges and lawmen in offices that were rarely filled by the same person for long.

Capital punishment remained a sentencing option for decades. Due to the festival atmosphere that surrounded executions, however, a 1903 law mandated that "all executions should take place within the walls of the [Oregon State] penitentiary, out of hearing and out of sight of all except officials." In 1914, the death penalty was abolished but was reinstated in 1920 after two especially gruesome murders.

County crime fighters also worked against illegal stills and morality issues such as prostitution or cursing in public places.

The crime of the 20th century was tried in St. Helens, when John A. Pender was charged with murdering Daisy Wehrman and her little boy, Harold. They were found bludgeoned and shot in their cabin in the Scappoose Hills on September 6, 1911. During a sensational, lengthy trial, strong circumstantial evidence pointed to Pender, who lived in a tent nearby. Circuit Court Judge J.A. Eakin sentenced Pender to death by hanging, and the Oregon Supreme Court upheld the conviction on appeal. However, Gov. Oswald West opposed capital punishment, and on November 19, 1914, he commuted Pender's sentence to life. Meanwhile, a mentally impaired neighbor took credit for the crime, and although the confession was found to not be authentic, public opinion of Pender's innocence grew. Finally, on September 11, 1920, Gov. Ben W. Olcott pardoned Pender. Pender was again captured in Portland, in October 1927, while attempting to rape a 15-year-old girl. After being convicted again, he was sentenced to the Oregon State Penitentiary, where he died in 1950. Governors West and Olcott would later express deep regret for interfering in the case.

Thomas McBride, an early teacher, also served as circuit court judge and chief justice of the Oregon Supreme Court. He wrote in 1928: "I think my teaching experience was of much practical benefit to myself, in that I acquired the habit of trying to make a clear statement of any proposition, and to make it so clear as to be within the comprehension of immature minds. In the practice of my profession, I not infrequently found immature minds upon the jury, and sometimes, I have thought, upon the bench."

On October 16, 1895, George Upton, 50, was jailed for the murder of William DeJournette. When a deputy sheriff left to get the inmates' supper, Upton locked his cellmate in another cell, pulled up some loose floor boards, and was seen leaving "at a rapid pace." Rearrested on December 11, 1897, he was convicted of second-degree murder in Judge Thomas McBride's court and sentenced to life in 1898. Gov. E. Chamberlain pardoned Upton in 1906. (Courtesy of the State of Oregon Archives.)

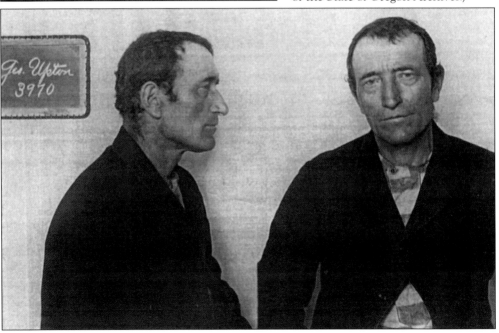

One of St. Helens's earliest attorneys, Frank A. Moore was appointed associate judge of the Oregon Supreme Court in 1892 and sporadically served as chief justice for the next 30 years. On October 18, 1918, Judge Moore spoke as grand senior warden at the dedication of the St. Helens Masonic Lodge.

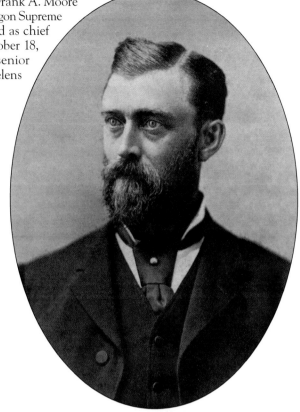

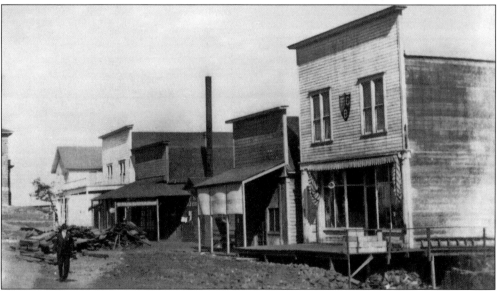

The Knights of Pythias, which organized in 1894 with 26 charter members, was one of many fraternal organizations that socially stabilized early St. Helens. Their building, at right, displayed their "FCB" logo, which stood for "Friendship, Charity, and Benevolence." The Masons, Odd Fellows, Woodmen of the World, and other groups were also active in the area.

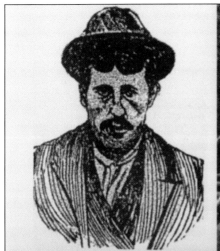
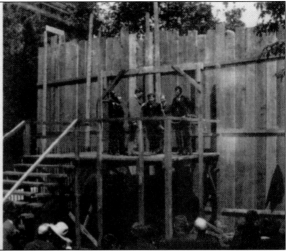

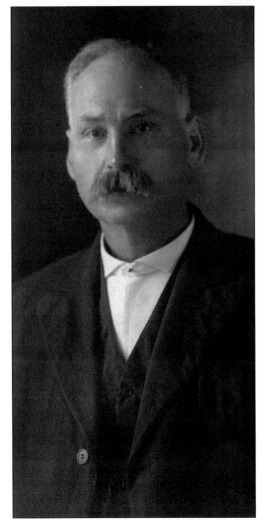

This sketch of Polish immigrant August Schieve appeared in the *Morning Astorian* on July 3, 1902, the day after his hanging in St. Helens. Schieve was found guilty of murdering Joseph Schulkowski but maintained his innocence to the gallows. Schieve's father, who watched the hanging from a courthouse window, was on his deathbed when he confessed to killing Schulkowski. The photograph at right, long thought to depict St. Helens's only hanging, is actually of the 1899 death of Claude Branton, in Eugene. It does represent how hangings were conducted, including the construction of a 12-foot wooden barrier and a passageway for transporting the condemned to the stockade that enclosed the gallows. A small number of people received engraved invitations and were allowed inside. At Shieve's hanging, 250 people stood in the rain to watch. (Left, courtesy of the *Morning Astorian*; right, courtesy of the Oregon Historical Society.)

Robert S. Hattan came to St. Helens in 1896 and served the public for 20 years, first as deputy sheriff, then sheriff, county judge, and treasurer. Known as "Honest Bob," he investigated Schulkowski's murder and oversaw Shieve's hanging. He also ensured that the courthouse was built at a minimum cost. Hattan was climbing the courthouse steps to his second-floor office when he suffered a stroke in 1917. (Courtesy of the Hattan Family Collection.)

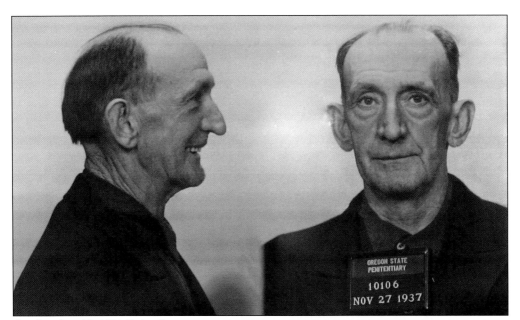

On October 13, 1914, Judge James A. Eakin sentenced John A. Pender to death by hanging for the murders of Daisy Wehrman, 35, and her four-year-old son, Harold. The trial and its appeals lasted for more than three years, and was one of the most publicized and controversial adjudicated crimes in Oregon history. (Courtesy of the State of Oregon Archives.)

Fannie Ross and her doughboy son, Cecil, pose on the porch of the Dr. L.G. Ross home. In his boyhood, Cecil was known as a practical joker who never passed up an adventure. He was a pilot in World War I, serving with 718 other Columbia County residents in various military branches. Of those, 16 would lose their lives, with six being killed in action. Injured in the war, Cecil returned home, attended medical school, and lived to age 85. (Courtesy of the Ross Family Collection.)

Dale Perry, pictured here with his son, George, had been city marshal for less than a year when he died in an on-duty motorcycle accident on November 22, 1924. Investigators stated that he lost control on Columbia Boulevard as he rounded the curve by what is now Ascension Lutheran Church. Perry crashed head-on into a telephone pole. He was survived by his wife, Elizabeth, and two sons under the age of four. (Courtesy of the Perry Family Collection.)

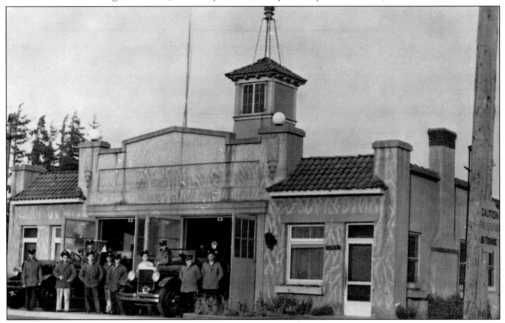

In 1928, St. Helens firemen and their equipment were housed on Columbia Boulevard. The department is at the same location today, though the firehouse was expanded and remodeled in 1982. Rex Hald can be seen at far right. (Courtesy of the Hald Family Collection.)

Sheriff John H. "Duke" Wellington led the battle against illegal liquor during his tenure in the 1920s. A February 4, 1921, newspaper article reported the sheriff's biggest bust in a vacant farmhouse: "No one apparently was on the premises, but the coal oil stove under the still was running full blast and the moonshine was dripping into a demijohn which was partly filled. The still was . . . capable of producing fifteen to twenty gallons per day. The sheriff poured out the mash and brought the still to St. Helens."

The spoils of a still operation are spread out on the courthouse lawn in this Prohibition-era image. Marshals used a Harley-Davidson motorcycle on their far-reaching patrols. (Courtesy of the Lillian Mickelson Collection.)

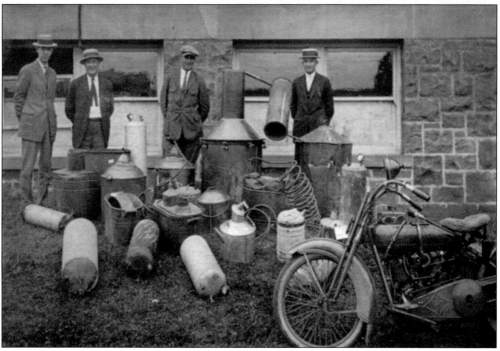

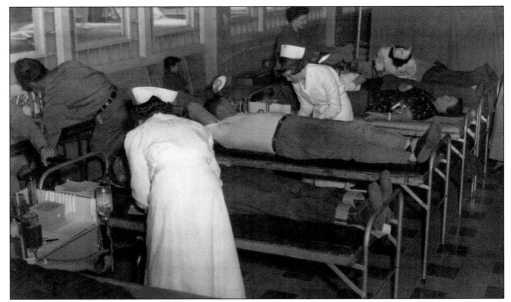

Starting in the mid-1950s, blood drives were an annual event at the paper mill, thanks to organizers Dale Cooper, Frank Weber, and Jim White. They, along with many others, have donated hundreds of units of blood. In 2005, the men were honored as "blood heroes" by the American Red Cross for their dedication to organizing drives and donating blood well into their retirement years.

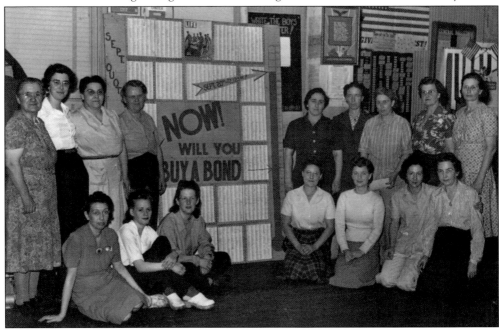

Bag Factory workers participated in World War II bond drives and had nearly reached their goal at the time of this 1943 photograph. Other local war efforts included victory gardens, rationing stamps and books, and letters to soldiers. Within months of the attack on Pearl Harbor, the federal government created the Beaver Army Ammunition Depot on the Columbia River at Clatskanie as a shipping point for arms and ammunition. Hundreds of thousands of tons of high explosives traveled through St. Helens by rail to Clatskanie for shipping to the Pacific Theatre.

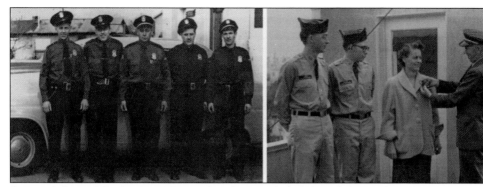

Seen at left in 1953, the St. Helens police force included, from left to right, John Evans, George Wyatt, Bill Mowrey, Victor Downs, and Chief Raymond Clark. In 1950, two-way radios were installed in city police cars and two fire trucks. "With the present system of [alert] lights on Columbia Boulevard, it has been necessary that one police car be detailed to keep within range of the lights at all times," reported the *Sentinel-Mist* in November 1950. The radios saved time in emergencies and offered protection. At right, Geneva Shadley is honored at the Civil Air Patrol observation post atop the fire station for her CAP work. In the 1970s, Shadley served on the St. Helens City Council until 1983, when she was appointed to complete the term of Mayor Frank Corsiglia, who died in office. In her eighties, Shadley was a citizen member of the county's Safety Committee. A year before her death at age 90, she was reappointed to a five-year term on the Northwest Oregon Housing Authority. (Left, courtesy of the St. Helens Police Department; right, courtesy of SHPL.)

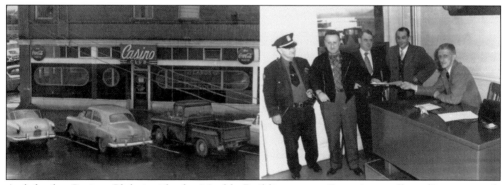

At left, the Casino Club, inside the Muckle Building, was a "no minors allowed" tavern with cards, pool, and even a small-scale bowling alley. In 1957, the Community Achievement Council wanted the space for the Pals Boys' Club of St. Helens. The *Sentinel-Mist* reported that the club would be used for "supervised recreation and play," and the Optimists' Club donated boxing equipment. Posing for the spoof photograph at right, District Attorney W.W. Dillard, second from left, was taken into custody in late December 1949 for failure to install Christmas lights in the plaza. The arrest followed a complaint filed by *Sentinel-Mist* news editor Bill Campbell. Dillard was cuffed to Chief of Police Warren Forsyth (left). To the right of Dillard are Judge J.W. Hunt, editor Campbell, and Judge Richard Singleton, who was reportedly "coerced without cash." (Left, courtesy of CPS; right, photograph by D.O. Bennett, courtesy of *Sentinel-Mist*.)

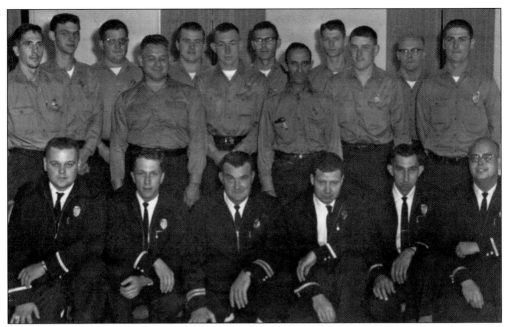

The St. Helens volunteer firemen gathered with the "regulars" in August 1963. The full-time, paid firemen are kneeling in the front row. They are, from left to right, Lee Broadbent, Gene Johnson, Chief Everett "Abe" Emerson, Irvin Brown, Percy Smith, and Assistant Chief Rollie Martin. Standing, from left to right, are volunteers Dick Willke, unidentified, Alvin Houghtelling, Levi Phillips, Clarence Houghtelling, two unidentified, Sam Baseel, Bob Thomas, Len Gartman, Floyd "Bud" Evans, and Ray Wallace. Calvin Jillson is not pictured. (Courtesy of the *Chronicle*.)

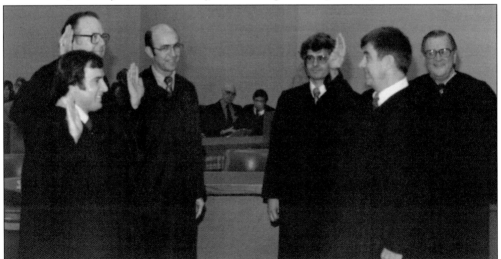

Columbia County's first resident circuit judge Don L. Kalberer was tapped to swear in new resident judges in early January 1981. From left to right are Berkeley A. Smith, James A. Mason, John F. Hunnicutt, Judge Delbert B. Mayer of Tillamook County, Kalberer, and District 19 presiding judge Thomas Edward E. Edison of Clatsop County. Kalberer was sworn in on July 1, 1968, at age 35. His remarks included a list of "commandments" he would abide by, including, "There are no unimportant cases," "Don't forget common sense," and, "Pray for divine guidance." (Courtesy of Don L. Kalberer.)

Seven

BACKBONE INDUSTRIES

"There has been a saw mill on the site of the present saw mill from the beginning of St. Helens," wrote a 1955 Woman's Club historian. The dense forests were the stuff of dreams for loggers, mill operators, shipbuilders, and paper-industry moguls. The waterfront was always chugging, and across the channel, oceangoing giants rose up from the beach at the St. Helens Shipbuilding Company.

Several basalt quarries opened, and local rock was shipped out for street paving, jetties, and rail beds. In 1908, the Columbia River Packers Association established a fish-buying station, building a dock in 1922. There, seiners could transfer their salmon catch, which would eventually be sold as Bumble Bee canned salmon. Western Cooperage made barrel staves and other components, while at the mouth of Milton Creek, two more McCormick enterprises, Fir-Tex and the creosote plant, flourished in the early 20th century.

Ownership of the "Big Mill" on the waterfront transferred to Pope and Talbot in 1925. A regional lumber strike in 1935 hit home—creating tough times for workers, straw bosses, civil authorities, and their families, all of whom wished for settlement and a return to everyday life. Eventually, that did happen, and by World War II, daily output increased to 400,000 board feet. One of the largest cranes on the Columbia ran the full length of the dock.

In 1926, St. Helens Pulp and Paper began its long and prosperous run. "It took the bleak days of the early thirties to make the citizens of St. Helens realize just how firmly the prosperity of their town is tied up with the destinies of the St. Helens Pulp and Paper Company," reported the Mist Publishing Company in 1943. Crown-Zellerbach acquired the business in 1953, manufacturing paper towels, bags, envelope paper, wrapping paper, tissue, and waxed paper. "Crown Z" also opened a green plywood plant. Later, the company was bought out by Boise Cascade, and steady local employment continued.

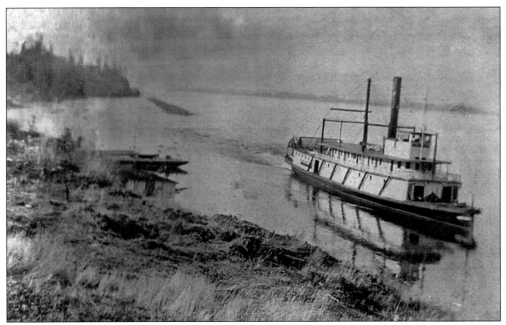

Looking north toward the Grey Cliffs promontory, a stern-wheeler tows a log raft in this pre-1900 photograph.

"Some Log"
"Eh Kid"
11000 feet

The photographic printmaker could not resist adding an editorial comment on the size of this log headed inside the Columbia County Lumber Company. Below it, a more typical-sized log is next on the belt. In the early 1920s, there was still first-growth timber in the woods.

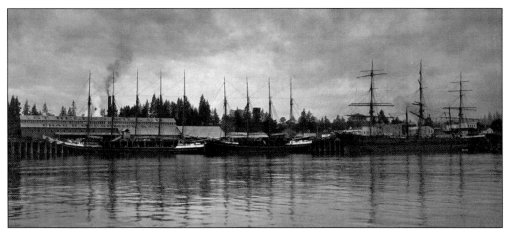

The St. Helens shoreline, viewed from the tip of Sauvie Island, shows the rooftop signage of the St. Helens Mill Company and Charles R. McCormick and Company beyond the sailing ships lying alongside the lumber docks. (Courtesy of the McCormick/ Perkins Collection.)

The saw filer, or "saw doctor," was a highly skilled position, responsible for keeping the sawmill's blades well maintained and repaired. Here a saw filer is pictured in his workshop, called the filing room.

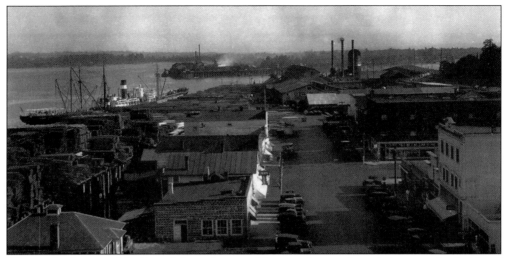

This southerly view of the Strand, from the top of the courthouse, shows industry on both sides of the channel. Island Mill and the St. Helens Shipbuilding Company are visible on distant Sauvie Island, and the McCormick Mill property crowds downtown businesses on two sides.

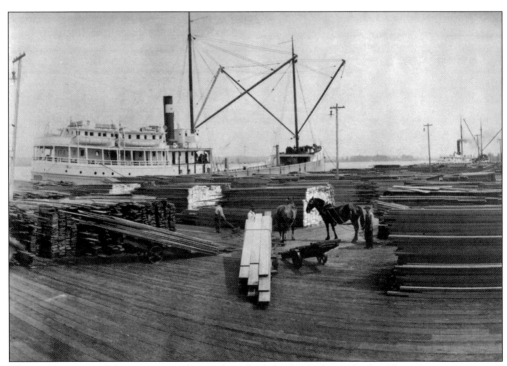

The *Celilo*—one of the great "auxiliary" ships built by St. Helens Shipbuilding Company—rests alongside the lumber docks in this early image, which dates to the times when horses were still used to move cargo. The *Celilo* was powered by a combination of engines and sails.

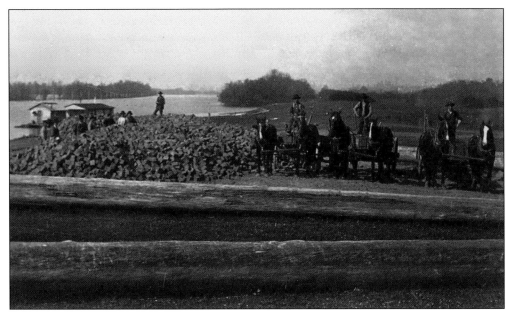

The Phillips brothers, Alex and John, were immigrants from Scotland who directed quarrying from multiple pits on the so-called King estate in 1907. Their company produced many tons of Belgian blocks for shipment by barge to Portland. Here, workmen pause near the Frogmore Quarry. (Courtesy of the Francis Anderson Collection.)

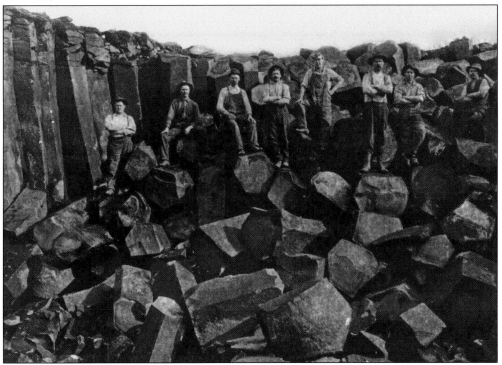

The unique shape of columnar basalt put local stone in demand in the early 1900s. The St. Helens Quarry Company operated in the Grey Cliffs area, on the north side of the city. In 1909, an estimated 300 men were employed in local quarries. (Courtesy of the Oregon Historical Society.)

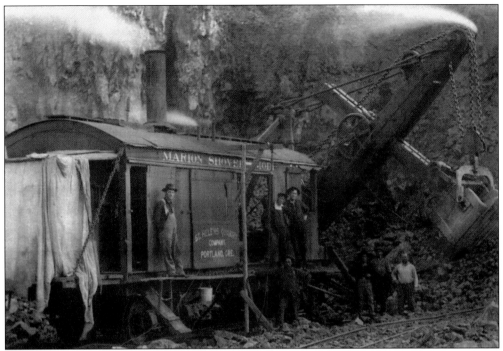

A quarry near the current location of the Elks Lodge provided pit-run basalt. A Model 40 Marion Shovel, powered by steam, scooped the material into a gondola that ran on moveable tracks next to the shovel, which moved on standard-gauge tracks. Here, Fred Christie stands near the boom. (Courtesy of City of St. Helens.)

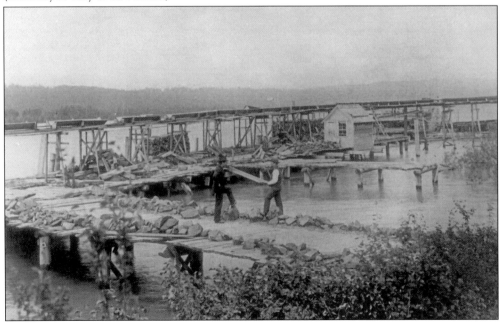

Well-known timbermen Herb Howard and I.J. Wikstrom move lumber on the dock, which is laden with rocks to keep it from floating off at high water. Behind them is a flume capable of carrying six-foot cordwood for steamers.

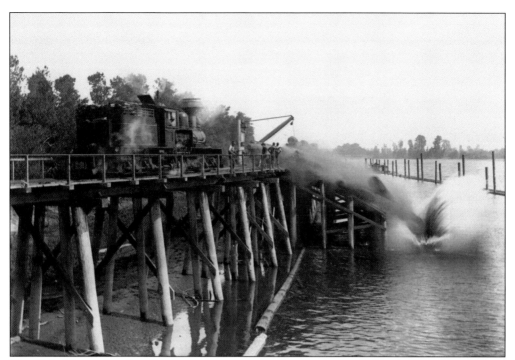

The C.C. Masten Lumber Company operated a railroad that transported logs from the Yankton area to the booming grounds on Scappoose Bay. When the railroad was abandoned in the late 1920s, Sykes Road was built on the old rail bed.

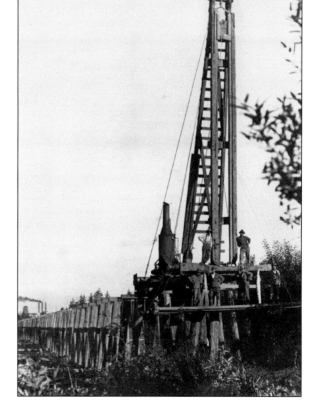

This immense, steam-powered pile driver created the grade for the St. Helens Dock and Terminal Railroad Company. In the distance, the McCormick Mill's stacks and characteristic "wigwam" burner is visible. The current tracks to the waterfront follow the same grade, but the area has been filled in. (Courtesy of Gayle Smith Harbison.)

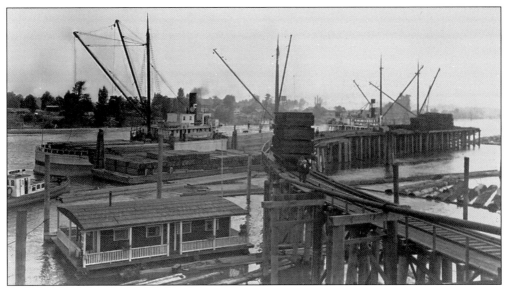

St. Helens Creosoting Company was jokingly referred to as a "tie pickling" plant. Founded in 1912 and superintended by Frank D. Beal, the company was the recognized authority on the creosote process. It was one of eight subsidiaries that in May 1925 merged into one corporation, the Charles R. McCormick Lumber Company of California.

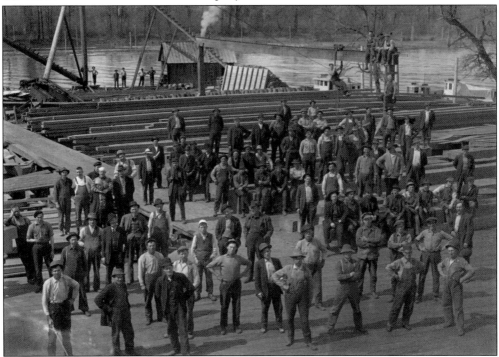

Charles and Hamlin McCormick grew richer with each new enterprise. In 1910, they founded the St. Helens Shipbuilding Company on the tip of Sauvie Island. Each new vessel launched drew hundreds from north and south, who watched the colossus slide into the Columbia. Few remnants of the operation are left—only a few pilings and blackberry overgrowth remains. (Courtesy of the Francis Anderson Collection.)

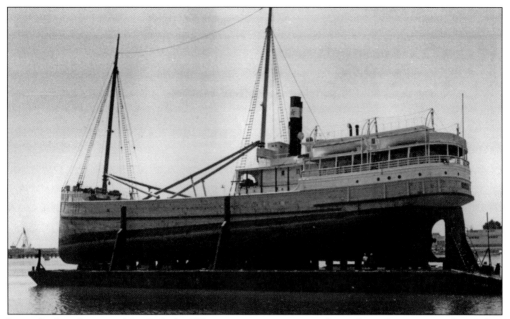

Launched on January 20, 1915, the *Wapama* was a two-masted wooden schooner, nearly 217 feet long. The hull was towed to San Francisco for completion. En route, the *Wapama* broke free, but the *Multnomah* completed the tow. The *Wapama* entered service in April, with a carrying capacity of 1.1 million board feet of lumber. In 1984, it was declared a National Historic Landmark. In 1988, the *Wapama* was on display at San Francisco's Maritime National Historical Park. The deteriorating ship was dismantled by August 2013, with significant parts and artifacts preserved for the maritime museum. (Courtesy of the Francis Anderson Collection.)

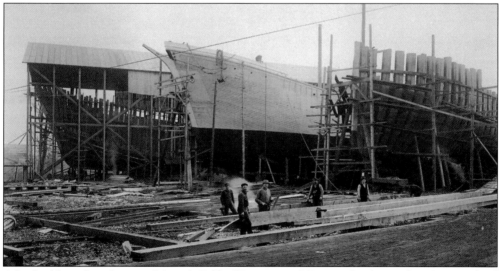

After building the schooners *Merced*, *Celilo*, *Wapama*, and *Everett*, the shipyard on Sauvie Island was working at capacity in 1916. Seen here at various stages of construction are the motorships *City of Eureka* (left) and *City of Portland* (center). Still to come were the *S.I. Allard* and the *City of St. Helens*. From 1911 to the early 1920s, the yard also turned out assorted ferries, launches, and barges. A preference for steel ships in the post–World War I market resulted in the business closing by the 1930s. (Courtesy of the McCormick/Perkins Family Collection.)

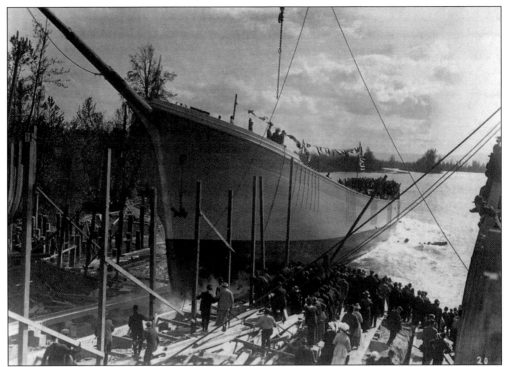

The 278-foot *City of Portland* was launched to much fanfare on April 15, 1916. The innovative "auxiliary schooner" style incorporated motors with sail power on wooden ships. She was equipped with five sets of sails as well as two 320-horsepower Bolinder internal-combustion engines.

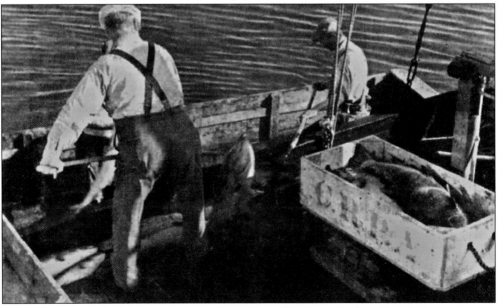

Edison I. "Pop" Ballagh (left), manager of the Columbia River Packers Association receiving station at St. Helens, is shown forking a fresh-caught salmon out of a pickup boat. Even before summer's end in 1955, the CRPA reported that 260,799 pounds of salmon had been delivered. (Courtesy of the *Sentinel-Mist*.)

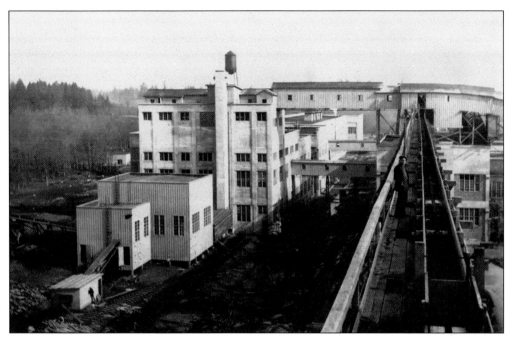

St Helens Pulp and Paper is pictured in 1928, just two years after opening. The country would soon be hit by economic disaster, but according to a 1943 article in the *Mist*, "The big plant, refusing to be daunted by the Depression, stayed open and in steady operation—and so did the town . . . St. Helens became known far and wide as a city which the Depression had failed to storm."

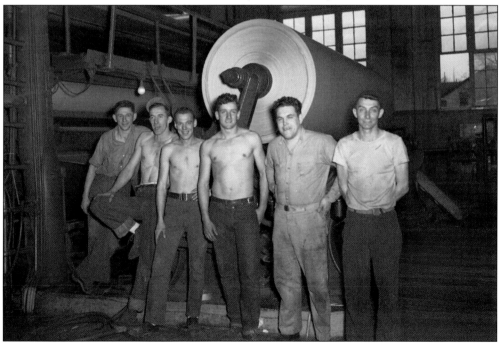

Mill workers at St. Helens Pulp and Paper often worked shirtless to cope with the temperatures. Landing a job at the paper mill often meant good pay and steady employment for the length of a person's career.

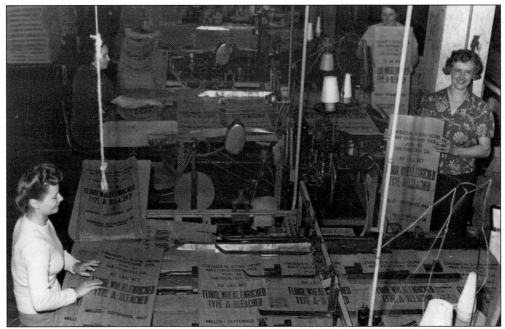

An arm of the pulp and paper mill was the Bag Factory, which in 1943 employed mostly female workers. The women operated machines to stitch a variety of bags—in this case, to hold bleached flour for the US Navy.

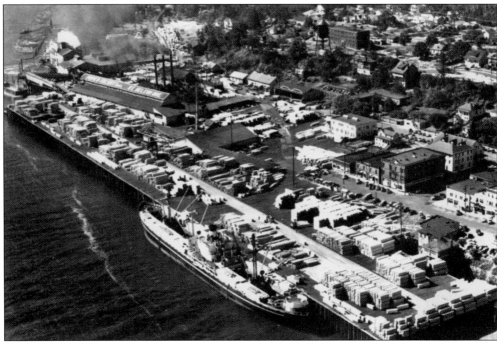

As Pope and Talbot Inc. prospered and its commercial docks expanded, the mill operation encroached into town. Today's Columbia View Park was later developed on the land in the lower right area of this photograph, where stacks of lumber and docks once edged toward the southern wall of the courthouse. Today, nothing remains of the mill. (Courtesy of CPS.)

Eight

Mayberry on the Columbia

Soldiers returning to St. Helens after World War II found work and then took advantage of their G.I. Bill benefits to become homeowners. As in much of the rest of the country, an economic boom and a prosperous mood spread to affect all aspects of life.

For St. Helens, this was small-town life at its best. Employment was largely local, and driving into Portland was for special occasions. Prosperity meant one car per household and usually one job as well. Children were raised by "the village" and were corrected and protected by neighbors.

Families indulged their children with dance lessons at the Elaine Haling Lease School of Dance, with swim lessons at the St. Helens Pool, Little League, Scouts, roller skating, bowling, Saturday matinees at the Columbia Theatre, and ice cream at the Dairy Delite (now the Dairy Delish). For outdoorsy families, there was the annual Salmon Derby, seasonal deer and elk hunts, camping, boating, or just driving around to view wildlife.

In the mid-1950s, the lighted Christmas Ships parade began in Portland. The event expanded to St. Helens in 1962, beginning a favorite annual tradition that continues today. Community leaders promoted parades, fireworks, and the county fair. Firefighters rolled out their equipment in the John Gumm School playground and demonstrated the strength of their fire hoses in competitions. The Port O' Fun carnival rides and booths drew people from throughout the county.

America was on its feet again, and St. Helens was a good place to live.

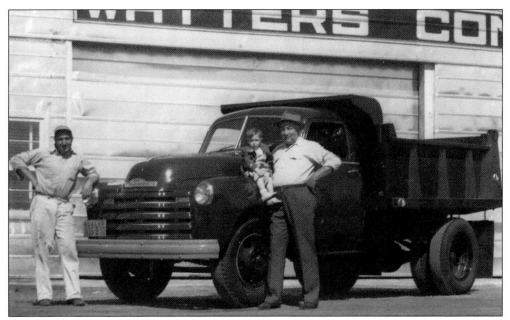

Three generations pose with a brand new Chevrolet dump truck in this 1948 photograph. From left to right are Fred Watters, little Leslie Watters, and Leslie "Tom" Watters. Tom started out loading gravel into wagons with a wheelbarrow in 1927 and then bought the Columbia Cement Company. His Watters Concrete Company is now owned by Knife River. (Courtesy of Les Watters.)

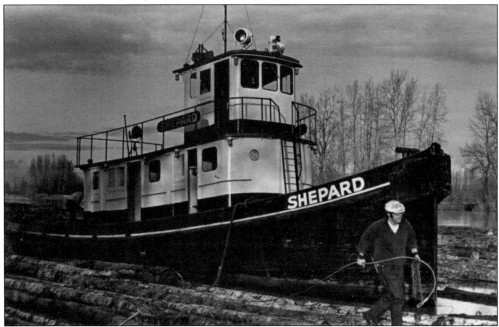

The Shepard Towing Company's tugboats were praised as "water tractors" in the *Sentinel-Mist*. Capt. Orin Shepard mastered big ships until 1914, when he joined his brother in a motorbus business. The river's appeal drew the captain back though, and he established the Shepard Towing Company and worked the waterfront for decades. Greg Korpela is pictured here rigging a log raft for towing. (Courtesy of Greg Korpela.)

In 1962, Emmy Lou Terrall was named Mrs. U.S. Savings Bonds in Fort Lauderdale, Florida, while competing as Mrs. Oregon in the national Mrs. America pageant. The 37-year-old mother of three would tour the nation as treasury volunteer goodwill ambassador. (Courtesy of Peggy Tarbell and Stan Mallory.)

St. Helens boosters towed this colossal log in a local parade. From left to right are unidentified, Art Albertson, Morris Keudell, and John Winkler. This single log would provide enough lumber to build a two-bedroom home. (Courtesy of CPS.)

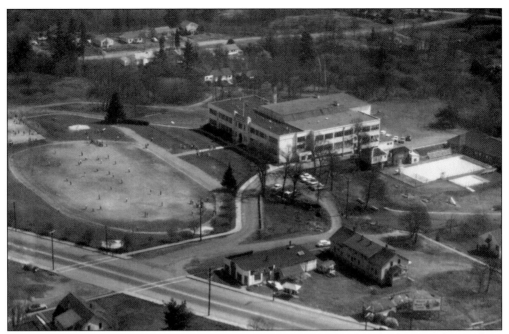

In the mid-1950s, L.D. Pat Cody flew over St. Helens High School with photographer Gilbert Crouse. Built in 1936, the high school was converted into a junior high in 1958. Next, the building was renamed Condon School in memory of Thomas Condon, the town's first teacher, and filled up with elementary students. In 1999, as Condon was demolished, contractors were erecting a new school alongside it named Lewis and Clark Elementary—set to open in fall 2000. (Courtesy of Sharon Cody Marsh.)

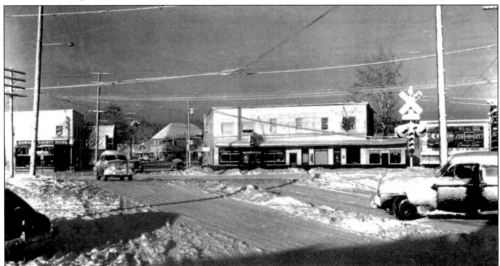

Kelley's Corner was a favorite drop-in spot near the junction of Columbia Boulevard and Highway 30. Aaron J. Kelley was born on his grandfather's Donation Land Claim in Houlton. As a lad, he helped his father, George, cut cordwood and clear the home farm and then worked in logging camps. In 1920, Kelley built this two-story business block. On the first floor, he ran a cigar and tobacco store and tavern, while other portions were leased for a restaurant and a barbershop. Upstairs were living quarters and hotel rooms. (Courtesy of CPS.)

Here, Dr. Lyle Ackerson administers the polio vaccine while nurse Loretta Wagner comforts their patient. After licensing in 1955, Dr. Jonas Salk's vaccine led to a dramatic nationwide drop in polio cases. By 1961, the *Journal of the American Medical Association* reported only 161 cases. The high school's football field was named Ackerson Stadium in the doctor's memory. (Courtesy of Peggy Tarbell and Stan Mallory.)

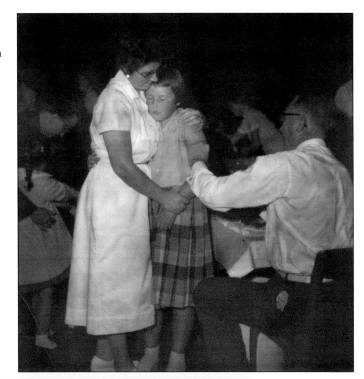

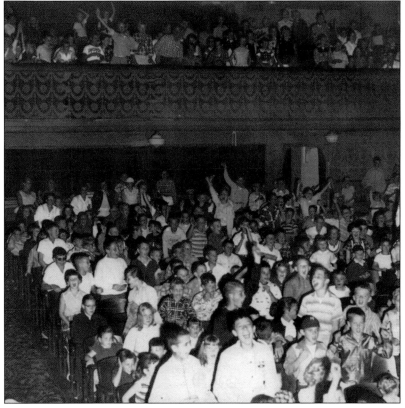

Both levels of the Columbia Theatre were packed every Saturday for double-feature matinees that included prizes and giveaways from the stage. Opened in 1928 as a vaudeville hall, the historic theater remains a popular attraction for children's feature films in after-school specials, as well as first-run movies. (Courtesy of Peggy Tarbell and Stan Mallory.)

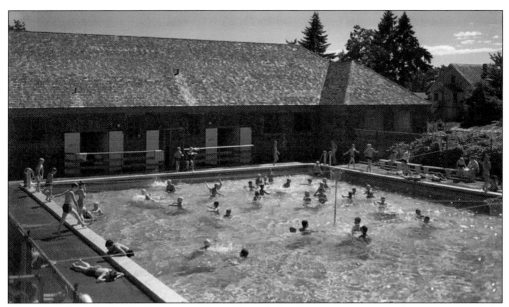

The St. Helens Pool, now known as Eisenschmidt Pool, was open-air until it was covered for year-round recreation. The natural rock building and low walls were built as part of a Civilian Conservation Corps project during the Depression. It was named for Herbert F. Eisenschmidt, who was hired as manager when it opened in 1939. "Mr. E," as he was known, taught and coached generations of swimmers, and remained a competitive swimmer at the national level well into his senior years. (Courtesy of CPS.)

This busload of happy high school students is headed out for an away game. Student numbers were swelling in the 1950s. Between 1940 and 1960, the Baby Boom and other factors led to a local population increase from 3,027 to 5,022. (Courtesy of CPS.)

The amazing feats of traveling Shrine Circus performers drew crowds to the St. Helens National Guard Armory in the 1950s. The site on Seventh Street, named Knighton Square, was set aside for public use. The armory was renamed for Maj. Sgt. Gunnar Larson, who was a respected member of the 186th Infantry for about 50 years. (Courtesy of CPS.)

The St. Helens Lion logo has changed considerably since it appeared on a drum in this 1949 band portrait. Bob Wayne was the band's president and manager, Harold Johnson was property manager, Mary Barr was secretary, and Lorraine LeMont was librarian. (Courtesy of CPS.)

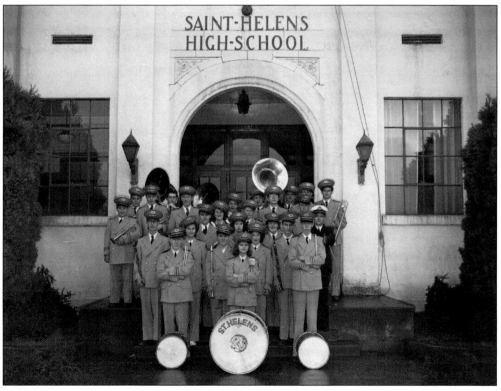

In this early 1950s photograph, a day spent competing in the annual Salmon Derby has ended with a weigh-in at the hardware store on the city docks, using a scale normally reserved for weighing nails. (Courtesy of CPS.)

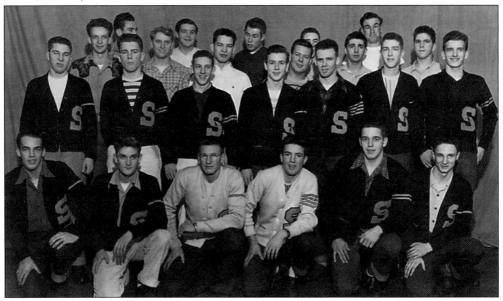

The outstanding male athletes of St. Helens High School formed the Hi-Y Club. Later, the group would be called the St. Helens Lettermen. The president was Kenneth Singleton, and officers included Vernon Bratsch, vice president; Howard Sullivan, secretary-treasurer; and Richard Bellingham, chaplain. (Courtesy of CPS.)

The local J.C. Penney first opened in 1925, and several years later moved to the first floor of the Knights of Pythias Hall on First Street. The department store was a retail pillar in town; in 1973, it moved to a new location in West St. Helens.

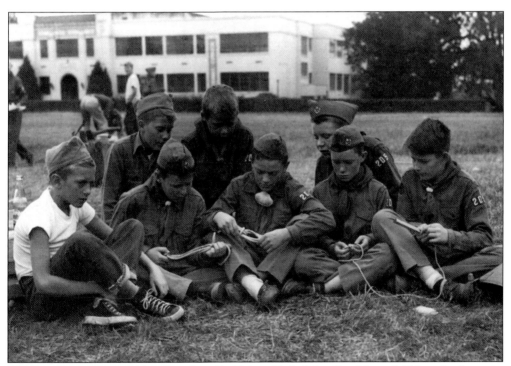

The Boy Scouts Troop 205 gathered on St. Helens High School's athletic field for a Jamboree in the early 1950s. In this group, Scouts were working on their knot-tying skills. Second from right in the front row is Henry D. "Perky" Carter. (Courtesy of SHPL.)

Ray Anliker and son pose with their five-point buck in the parking lot of the John Gumm School. In the years before pickup trucks were common, hunters lashed their game to the hoods or roofs of their cars. (Courtesy of SHPL.)

Jack Keudell Motors provided a custom-made Pontiac for training young drivers in 1951. It was equipped with brakes and a throttle for both teacher and student. Among the teenagers pictured here are Ardene Kelly, Joanne Larson, Karen Haquist, and John Scott. (Courtesy of SHPL)

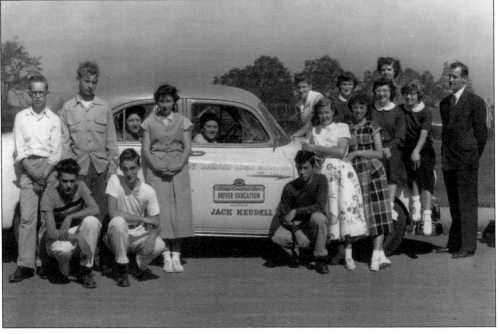

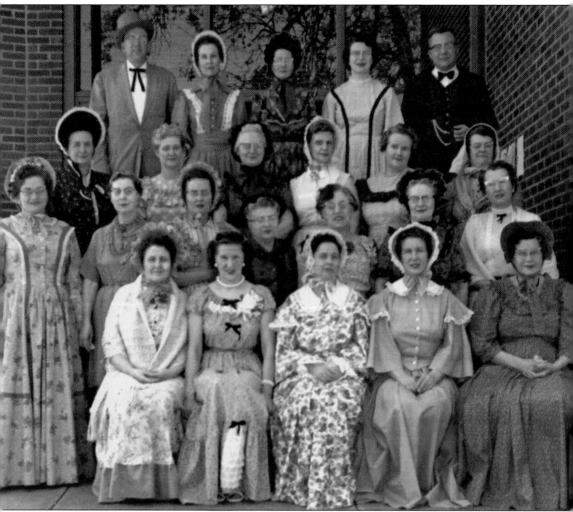

In recognition of Oregon's statehood centennial in 1959, McBride School faculty dressed as pioneers. From left to right are (first row) Evelyn McFarlane, Adeline Otto, Mavis Printz, Irene Putman, and Principal Belle McCrummen; (second row) Eleanor Bradley, Thelma Henderson, Edith McLagan, Orah Johnson, Mureil Rice, Hildur Peterson, and Irene Heibel; (third row) Mildred Boulby, Lorma Douglas, Edna Wickman, Ethel Ellis, Hazel Chappel, and Anna Ragland; (fourth row) Superintendent Elwood Egelston, Ann Zaniker, Pauline Butts, unidentified, and Jack Manges. (Courtesy of SHPL.)

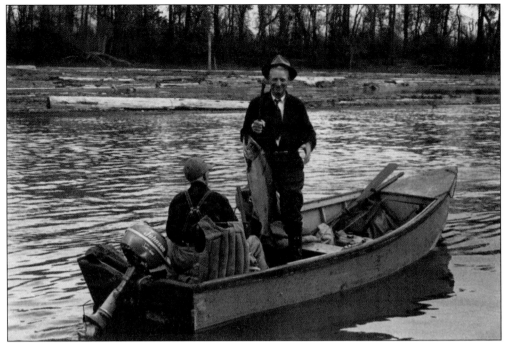

Joined by an old friend, Ed Slausen is the well-dressed angler showing off his catch. Commercial and recreational fishing continued locally throughout the mid-century years, and the annual Salmon Derby offered enticing prizes.

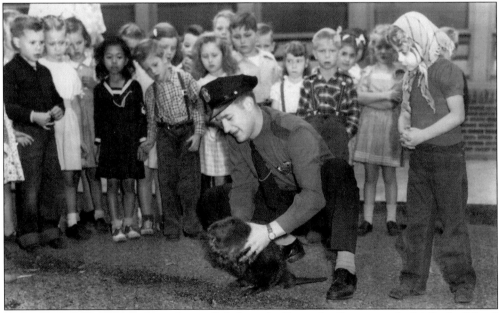

In October 1947, city patrolman Irving Pyle brought Eager the Beaver to the McBride School for a show-and-tell before the animal's release. Marie J. Amala of Portland had hand-raised the beaver kit. When Eager was six months old, Amala read that St. Helens wanted to reintroduce beavers for dam-building. Eager was released at a spot on Milton Creek where five other beavers had been placed earlier. (Photograph by Gilbert Crouse, courtesy of *Sentinel-Mist*.)

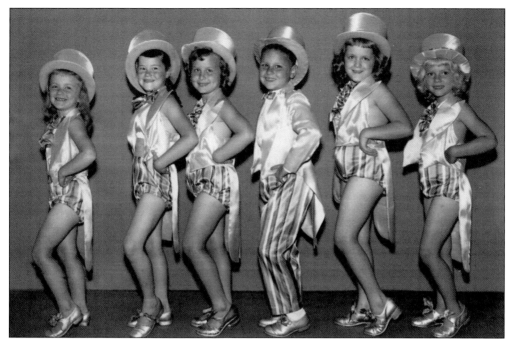

Hundreds of St. Helens children have passed through Elaine's Dance Studio. Taught by Elaine Lease, families could count on the school to hold an annual program, complete with costumes, to demonstrate their children's progress. Before retiring, "Miss Elaine," was teaching the grandchildren of her former students. (Courtesy of Elaine Haling Lease.)

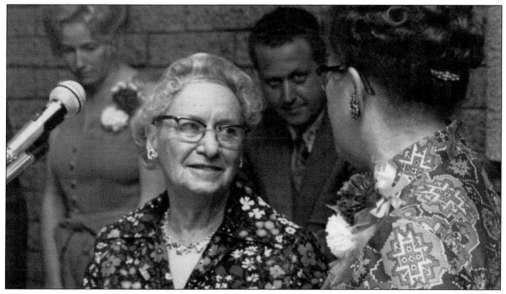

Chuck and Irmadawn Brownlow look on as Elsie Zatterberg presents the 1968 Finest Citizen Columbia County Fair award to Pearl Becker. Becker was a beloved local historian, 4-H leader, and Grange member who taught spinning, weaving, and basket making. She belonged to the Daughters of the American Revolution, Sunset Park Community Church, and Rebekah Lodge. She is warmly remembered for helping to establish a historical society in 1930, reviving it in 1949, locating sites for a museum, and diligently researching and writing about local history.

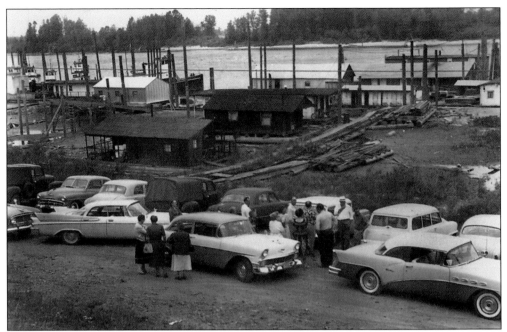

Lucille Holbrook led a coalition of 60 organizations and clubs to make improvements to St. Helens in the 1950s. All over the city, volunteers donated time, money, and materials for clean-up, painting, and fix-up projects—from establishing parks to beautifying buildings. The result was a $10,000 prize and a national Community Achievement Award in 1959. Here, a group visits the city docks with a critical eye for improvement. (Courtesy of the Woman's Club Collection.)

More than one mom-and-pop grocery store served St. Helens. In 1938, Bud and Nora Crosby operated a store (now Zatterberg's) across from a long-vacant Texaco station. In 1940, they purchased the abandoned property and operated Crosby's Grocery there through 1956. Their daughter remembered that their first bathroom was the Texaco restroom—"the only outhouse in town with a flush toilet and an added shower." The store was later named West Street Grocery. (Courtesy of Janet N. Crosby Adams.)

Nine

RISING UP FROM STORMS

Even 86 miles from the ocean, St. Helens experiences a four-foot tidal fluctuation, and annual spring flooding is unpredictable. For Milton, what did not wash away in the 1861–1862 flood was carried off in 1894. Residents started over upstream, founding Houlton.

The 1894 storm and flood was a historic anomaly. Bella Metcalf, then a girl, remembered pounding rain, lightning illuminating black clouds, and trees toppling. Then, she and her mother glimpsed the *Iralda* riding a huge swell on the river. "It picked up the [ship], lifted it out of the river, and dropped it on the railroad tracks running along the bank," wrote one *Oregonian* reporter. "A second later, a second giant swell plucked the riverboat off the tracks, returning it to the river."

Fueled by wind, a fire tore through town early on September 14, 1904, wiping out most of the business district. Charles and James Muckle lost their mill, store, and warehouse, valued at $14,000. Homes and businesses burned. The *Mist* reported, "Had it not been for the earnest efforts of the citizens, the block in which the courthouse is located would also have been destroyed." The writer emphasized the need for a new courthouse "that will give assurance of safety against future fires."

In 1948, a devastating flood inundated homes, mills, and the creosote plant. Then, 10 years later, the Columbia River Packers Association dock burned amid fuel-tank explosions. City dock businesses owned by the Dahlgren and Watters families were destroyed.

The Columbus Day Storm of October 12, 1962—with its gale-force winds crushing barns, killing livestock, and uprooting trees—remains etched in local memory even today. Pearl Becker recounted: "In the twilight we could see the trees in our yard writhing and twisting, and before we had finished eating our dinner, we heard something hit the corner of the house. It was a plum tree that took out the electric lines with it." The giant redwood tree near Milton Creek withstood the phenomenal wind, she said, and "stood rigid throughout the gale."

Like the redwood, St. Helens has withstood all that Mother Nature has thrown its way. And it is still standing.

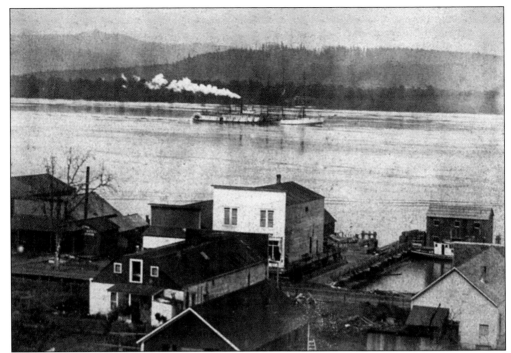

On June 7, 1894, the largest flood in recorded local history came as the result of snowmelt and heavy rains. The river rose to 33 feet before it was over. At Deming's Drug Store, along the Strand, pharmacist Dr. Edwin Ross moved prescription drugs to the attic, and customers used rowboats to pick up their medications from a window. (Courtesy of the Deming Family Collection.)

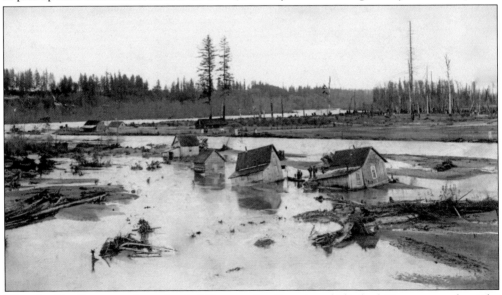

Historian Roy Perry, grandson of early Milton settlers Francis and Elizabeth Perry, wrote about the town's demise in the *Sentinel-Mist*: "It was after the big high water floods of the winter of 1861–62 and the equally high freshet of June 1894 that Milton was carried away and off downstream—lock, stock, and barrel. It was then that the principals chose to move up Milton Creek about two miles to establish a second location."

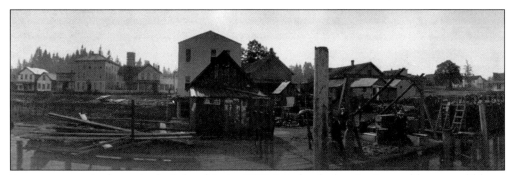

Passengers await the arrival of the ship in 1903. Much of what is pictured here would burn in the massive fire of 1904. Many of those who suffered losses were not insured. The wooden courthouse—the Seth Pope House—visible near the tree at far right, was spared.

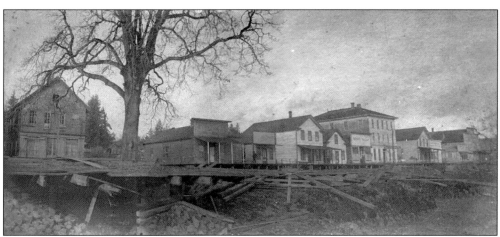

Business owners built along the waterfront near the "Lewis and Clark oak tree," and their docks were undermined by flooding. In this pre-1904 photograph, from left to right are Tammany Hall, which housed a meat market and boarding rooms; Tom Cooper's Saloon; the law offices of Moore and Quick; Joe Conkel Hotel; the drug store, operated by Edwin Ross; Brinn's Saloon; the Oriental Hotel (three-story building); and beyond it, the Geo. McBride and Giltner general store and post office. The entire block burned on September 14, 1904.

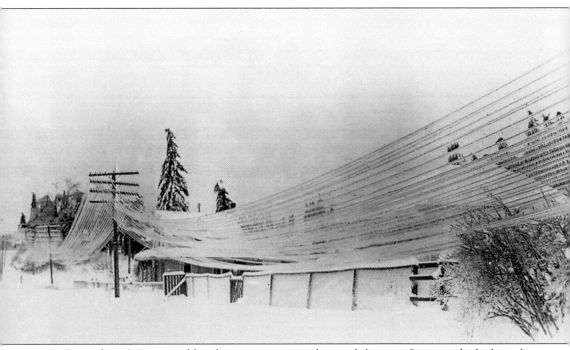

In December 1919, a record-breaking winter storm slammed the area. Power and telephone lines along South Second Street, at Columbia Boulevard, drooped with the weight of the ice. Weather observers noted that the Columbia River was frozen. That winter still holds various records for extreme cold and long-lasting snow.

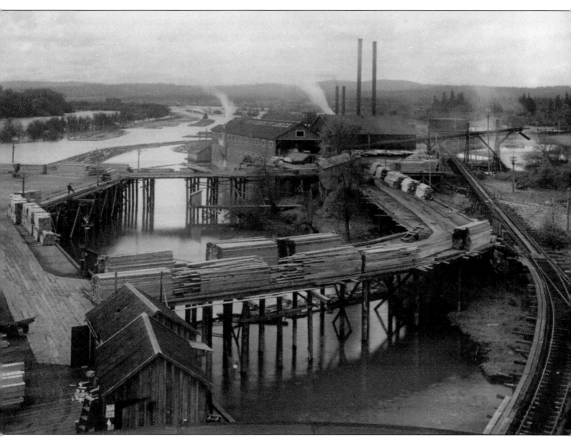

In 1913, the Columbia County Lumber Company was located near the mouth of Milton Creek but it would burn down on April 23, 1923. The loss was estimated at $200,000, including the mill, boiler plant, 1,000 feet of trestle, and a tank owned by the Milton Creek Logging Company. About three million feet of lumber waiting on the dock for shipment also burned, along with several boxcars belonging to the Spokane, Portland, and Seattle Railway. The mill had employed about 160 men. Afterward, the McCormick brothers obtained part of the mill site to expand their creosote plant. (Courtesy of the Francis Anderson Collection)

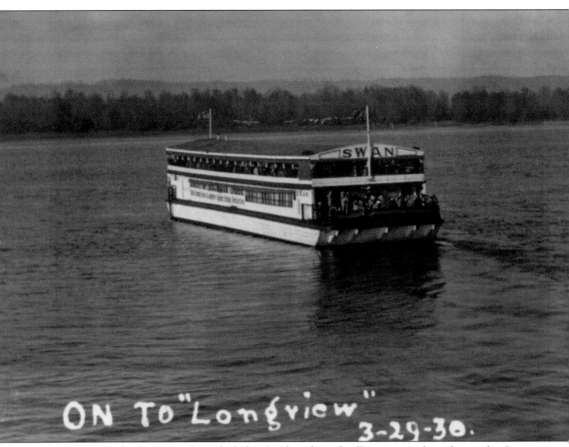

ON TO "Longview" 3-29-30.

Late on March 30, 1930, a heavily laden lumber ship, the *Davenport*, plowed into the *Swan*, a double-decked excursion barge under tow. It carried 289 people returning to Vancouver after celebrating the opening of the new Longview Bridge. As the orchestra played, the ship loomed out of the darkness and the screaming began. It crushed the bow, upending the barge, and sank its towboat, the *Dix*, in 30 feet of water. "Dozens of persons were hurled into the murky waters," reported the Associated Press. Seven died, and another dozen were hospitalized. (Courtesy of the Clark County Historical Museum.)

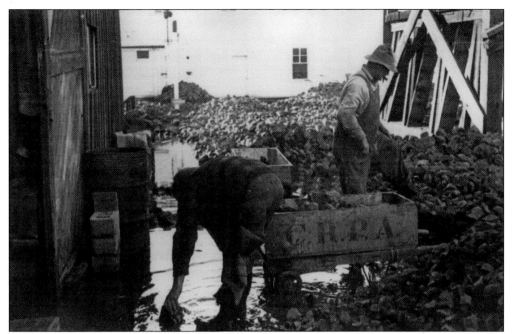

Bob McKie (right) and an unidentified man load rock into a Columbia River Packers Association fish cart. The rock kept the city dock from floating away during the 1948 flood. Homes and businesses along the waterfront, as well as the city and commercial docks, were threatened.

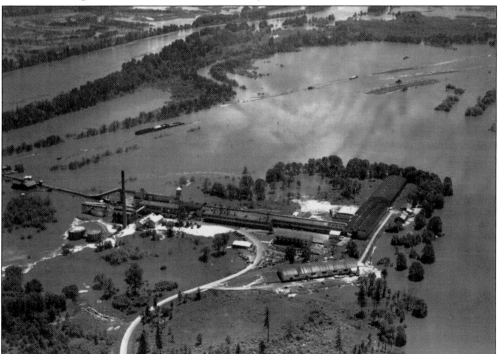

The swollen river surrounded the paper mill in the June 1, 1948, flood. Multnomah Channel, the Columbia River, and Milton Creek all rose above any flood stage that locals had ever witnessed. Newly built dikes on Sauvie Island barely held back the floodwaters. (Courtesy of CPS.)

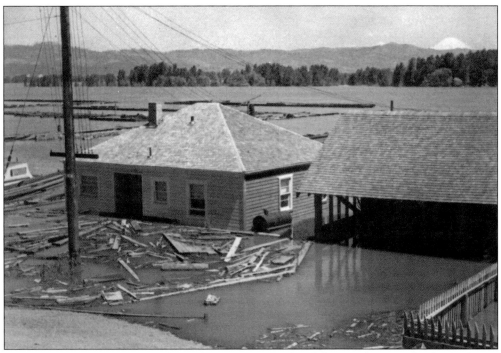

Homes along the Strand were filled with river water for days following the 1948 flood. This house was dried out and repaired. It still stands near the St. Helens Marina on the north side of town.

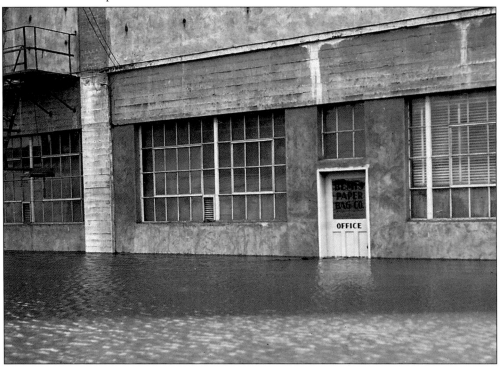

In June 1948, the former offices of Bemis Paper Bag Company, as well as other industrial sites near the river, suffered flood damage. (Courtesy of CPS.)

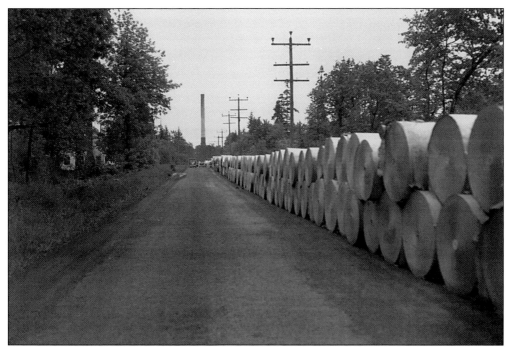

In 1948, massive rolls of paper were moved from the St. Helens Pulp and Paper mill to higher ground until the floodwaters subsided. (Courtesy of CPS.)

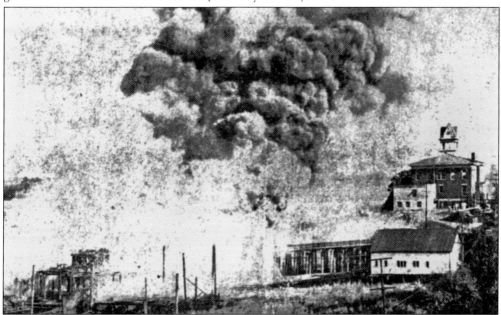

More than 2,000 people watched on August 18, 1956, when a devastating fire burned the Columbia River Packers Association dock and the businesses on the City Dock. Fire Chief Mike Basee suggested that the fire originated in a CRPA shack where fishermen hung their nets. Further disaster was averted when police sergeant Buddington broke into the Dahlgren Building and, with four other men, carried out more than 350 pounds of dynamite—stored there for Portland General Electric Company. (Courtesy of the *Oregon Journal*.)

119

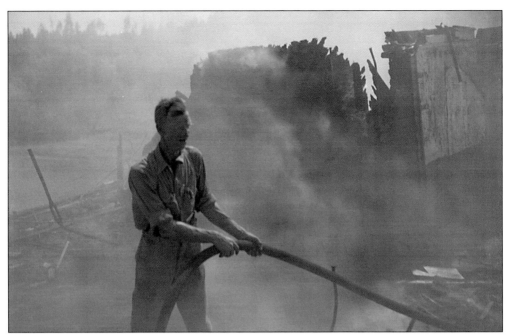

In the aftermath of the August 1956 dock fire, workers sort through debris. When the 500-gallon fuel tanks exploded, flying shrapnel was visible in Houlton. Strong winds whipped the flames and carried embers up to 100 feet away. A boat moored beneath the CRPA packing plant dock was crushed by falling timbers. (Courtesy of CPS.)

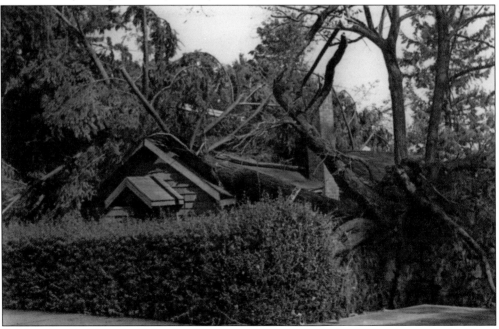

On October 12, 1962, the Columbus Day Storm swept through the region, destroying buildings and uprooting trees with gale-force winds. Power outages were extensive. St. Helens High School teacher Olive Moffitt was killed at Rose Manor Trailer Court when her carport was blown over. Several area barns were destroyed, as well as some cattle.

Ten

NEARLY FAMOUS

Fame is for a season, and the town once known as "Shipbuilding City" and "Payroll City" is now known for other reasons. Its close brushes with fame are as varied as their sources—haunted spots making national television, famous descendants of town founders, the notoriety of a 1969 rock festival gone wrong, and the town's selection as a location for a couple of memorable movies.

Actress Debbie Reynolds and a film crew arrived in the late 1990s for the making of *Halloweentown*, a Disney Channel made-for-TV movie. The film's legacy is seen in St. Helens each October, with the Spirit of Halloweentown celebration, which includes scarecrow contests, pumpkin carving, and spooky tour guides leading history walks around downtown. The words "City Hall" appear on the old courthouse to recreate the movie's look, and a replica of the giant pumpkin seen in *Halloweentown*—designed by Byron Ohler of Michael Curry Design—takes its place at the center of the plaza.

St. Helens's maritime history—its massive shipyard and bustling waterfront lined with four- and five-masted ships—is largely unknown to most of today's residents, but talk about the filming of *Twilight*, and they nod their heads. Fans of Edward and Bella come from all over to seek out the places they saw in the 2008 movie. Sites include a home on Sixth Street, the movie's "Swan House," narrow alleyways between downtown buildings, and businesses that served as the Bloated Toad Restaurant, Thunderbird & Whale Bookstore, and Petite Jolie–Angel Hair Salon. The actresses were also filmed in Jilly's, where they shopped for prom dresses. Locals delighted in seeing their own courthouse on the big screen, as well as the Columbia Theatre in a nighttime car chase down First Street.

Ghosts, witches, and vampires certainly provide a different brand of fame, but reach a much wider audience.

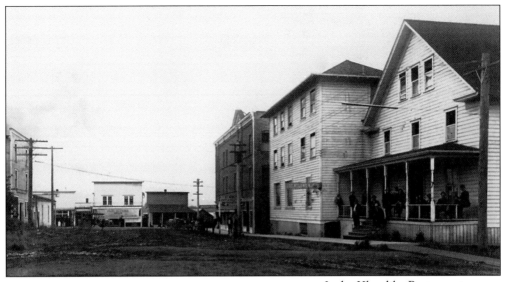

Is the Klondike Restaurant and Bar haunted? Many say "Absolutely." The three-story structure (center) was annexed by the St. Helens Hotel more than a century ago. The hotel itself was torn down in 1954, but the annex remained and has changed hands over the years. Stories of hauntings developed as well, from a vision of a little boy standing near the bar and a coffee maker starting itself, to smashed glassware. Voices were recorded at the site by the West Coast Specter Society, and in 2010, the Klondike was featured in the A&E series *Paranormal State*.

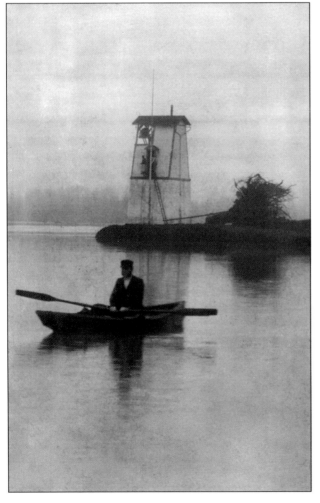

The country's smallest lighthouse sits atop Warrior Rock on Sauvie Island. Built in 1889, the structure was refurbished in the 1930s and faithfully directed river traffic until a barge struck it on May 27, 1969. After repairs, it went back online and is still in service. It once housed the oldest fog bell in the Northwest—cast in 1855. After the barge accident, the bell was damaged during removal. Now mended, it sits by the County Courthouse Annex entry.

The giant redwood tree at Milton Way and DuBois Lane is often called the Meeker Tree, for the enduring myth that Ezra Meeker brought the sapling from California in a carpetbag in about 1894. The property was once the Donation Land Claim of Susannah Franz (Mrs. Aaron Boyles), who filed before July 1855. Their daughter married George R. Kelley on May 2, 1875, and the couple lived there until 1891, when they sold the land to Ezra's cousin Lindley. Lindley had, in 1874, planted a redwood in Ridgefield, Washington, where he lived at the time. Some believe he planted this tree in 1891, but photographs from 1912 show a 100-foot tree. In Volume II of their *Columbia County History* publication, the St. Helens Historical Society declared, "It seems it must have been planted when the Kelleys lived there." In 1959, Nina DuBois owned the property.

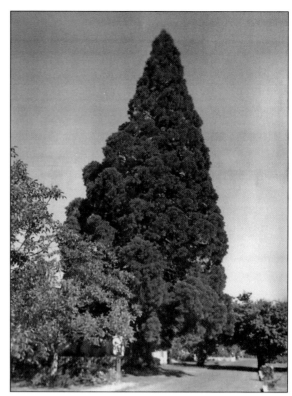

One of America's leading painters, N.C. Wyeth is descended from Bostonian Nathaniel Wyeth, who landed here in 1834 and named the area Wyeth's Rock. An Oregon Trail pioneer, Nathaniel was already rich from inventing ice-harvesting tools and opened a trading post on Sauvie Island. Among his descendants are three generations of eminent painters: N.C., Andrew, and Jamie Wyeth. Another son of N.C. Wyeth, Nathaniel Wyeth, invented the plastic soda bottle. (Courtesy of Archives of American Art.)

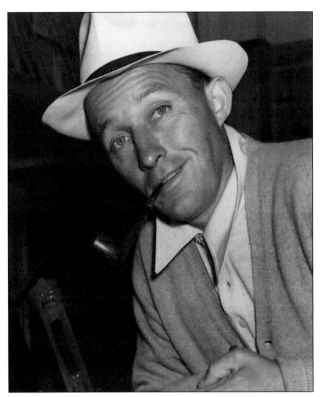

From 1934 to 1954, singer and actor Bing Crosby was America's first multimedia superstar in music, film, television, and radio. Bing was descended from Capt. Nathaniel Crosby, who with Thomas Smith founded Milton in the late 1840s. In 1852, Captain Crosby took a cargo of spars from St. Helens to Hong Kong—the first shipment from the Pacific Coast forests to the Orient. He died during a later excursion to Hong Kong and was buried there.

DON'S

FAMOUS HAMBURGERS

SUPER-CREAMED ICE CREAM

GIANT MILK SHAKE 10c

(No Extra Charge for Malt)

EXTRA THICK — HEAVY IN FOOD SOLIDS — RICH IN VITAMINS

24 DELICIOUS FLAVORS

Vanilla	Tom and Jerry	Caramel	Banana
Chocolate	Lemon and Lime	Butterscotch	Concord Grape
Strawberry	Lime	Black Walnut	Marshmallow
Pineapple	Raspberry	Maple	Peanut Butter
Lemon	Wild Cherry	Coffee	Peppermint Candy
Orange	Grenadine	Toffee	Custard

GIANT ICE CREAM SODA . . . 10c

HAMBURGERS—A SPECIALTY

Old Fashioned (Onions and Pickles)	.10
Aristocrat (Mayonnaise, Relish and Lettuce)	.10
Cheeseburger	.15
Eggburger	.15
Deluxe (Bacon, Tomato, Mayonnaise, Relish and Lettuce)	.20
Royal (Bacon, Cheese, Mayonnaise, Relish and Lettuce)	.20

SANDWICHES		ICE CREAM	
Tuna Fish Sandwich	.15	Banana Split	.15
Egg Sandwich	.10	Sundaes	.10
Cheese Sandwich	.15	Tulip Sundae	.15
Ham and Cheese Sandwich	.20	Double Sundae	.15
Hot Dog	.10	Double Dish	.10
Cold Ham Sandwich	.10	Giant Hi Packs,	
Fried Ham Sandwich	.15	quart	.50
Ham and Egg Sandwich	.20	Giant Hi Packs,	

(No Extra Charge for Toasting)

Remember the above sandwiches with one of our delicious milk shakes makes an ideal lunch.

Roy Rogers

SPECIALS

Pie a la Mode		Hamburger Steak	.40
Cake a la Mode	.10	Ham and Eggs	.45

3-16-41

Special Banquets on 24 Hours Notice In Private Banquet Rooms

Roy Rogers performed at the Columbia Theatre on two occasions. While we do not know what he chose for lunch, Rogers autographed a menu at Don's Restaurant, marking the date as March 16, 1941. (Courtesy of the Wicks family.)

In 1968, Robert F. Kennedy was campaigning in the presidential primary against Senator Eugene McCarthy when his tour took him through St. Helens. Although he won the primaries in Indiana, Nebraska, South Dakota, and California, Kennedy lost the Oregon primary to McCarthy, 44.7 percent to 38.8. In the early hours of June 5 that same year, Kennedy was assassinated while leaving the Ambassador Hotel in Los Angeles.

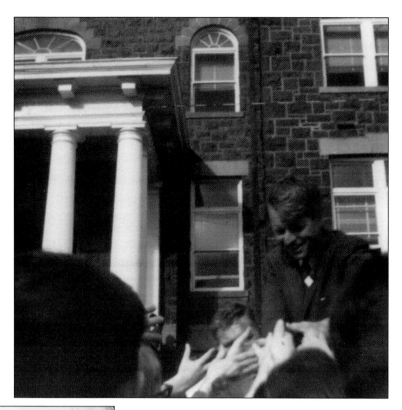

July 4–6, 1969, saw the Bullfrog rock festival at Bull Frog Lake, Estacada. It was so successful that organizers arranged for Bullfrog 2 in August, at the Columbia County Fairgrounds. As people were arriving, circuit court judge Glen Heiber ruled that the fairgrounds were not adequate for an event of that size. District Attorney Lou L. Williams found a loophole in the contract, allowing the county to suspend the event, so the "hippies" protested by gathering on the plaza with their sleeping bags and good moods. Melvina Pellitier offered her Happy Hollow property as a replacement, and The Grateful Dead played at Bullfrog 3 that weekend. (Courtesy of David Freytag.)

Fans of *Halloweentown*, the 1998 Disney Channel movie, recognize the Columbia County Courthouse as the fictional location's city hall. Starring Debbie Reynolds, the movie remains an annual favorite and spawned the theme for St. Helens's hometown celebration, Spirit of Halloweentown. The festival is centered in the plaza, with spooky tours by local actors, kids' events, a citywide scarecrow contest, and—at the heart of it all—a replica of the gigantic pumpkin from the movie. (Courtesy of Josh Garafola.)

Robert Pattinson played the most beloved vampire of the 21st century in the *Twilight* series. Many scenes were filmed in St. Helens, to the thrill of Stephanie Meyer fans. (Photograph by Eva Renaldi; CC license.)

St. Helens fans cheer on their favorite son, Derek Anderson, quarterback for the Carolina Panthers. Anderson grew up in Columbia County, and his family still calls St. Helens home. In the 2005 NFL draft, Anderson was picked by the Baltimore Ravens in the sixth round, and played for the Cleveland Browns and the Arizona Cardinals before joining the Panthers in 2011. (Photograph by Keith Allison; CC license.)

Actress Katee Sackhoff spent her early childhood in St. Helens. She is best known for playing the role of Kara "Starbuck" Thrace on *Battlestar Galactica* from 2003 to 2009. Among her other film and TV appearances, Sackhoff currently stars as Deputy Sheriff Victoria "Vic" Moretti on the popular series *Longmire*. (Photograph by Gage Skidmore; CC license.)

DISCOVER THOUSANDS OF LOCAL HISTORY BOOKS FEATURING MILLIONS OF VINTAGE IMAGES

Arcadia Publishing, the leading local history publisher in the United States, is committed to making history accessible and meaningful through publishing books that celebrate and preserve the heritage of America's people and places.

Find more books like this at
www.arcadiapublishing.com

Search for your hometown history, your old stomping grounds, and even your favorite sports team.

Consistent with our mission to preserve history on a local level, this book was printed in South Carolina on American-made paper and manufactured entirely in the United States. Products carrying the accredited Forest Stewardship Council (FSC) label are printed on 100 percent FSC-certified paper.

MADE IN THE USA